THE CHAIR

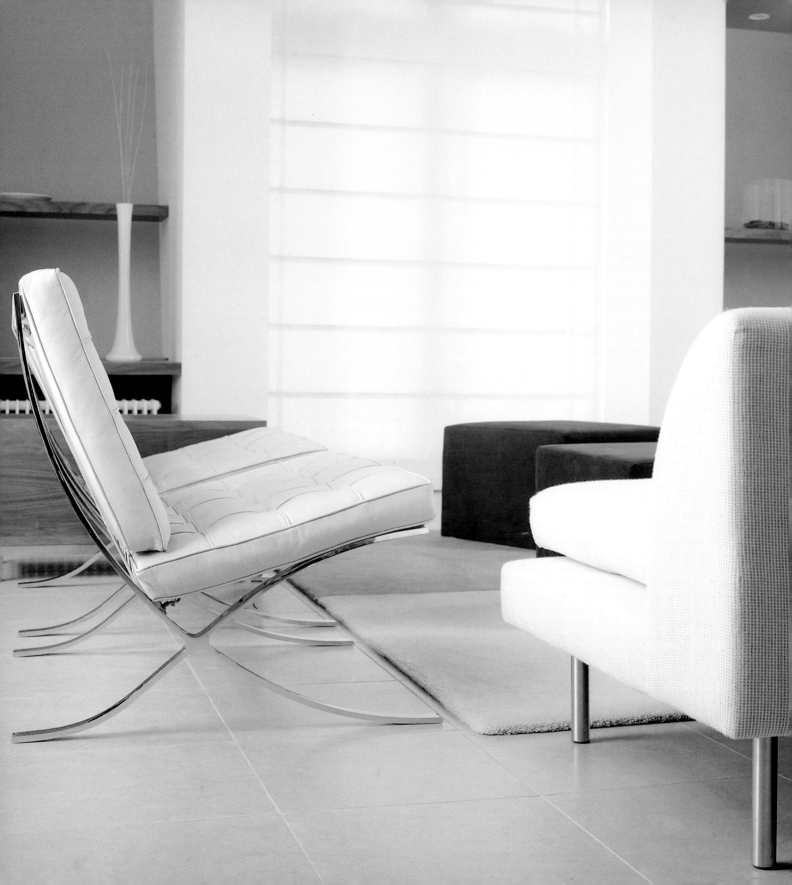

LIVING WITH MODERN CLASSICS

THE CHAIR

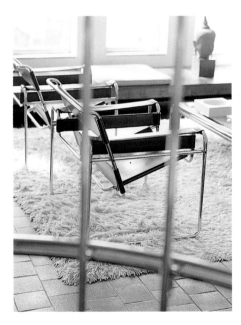
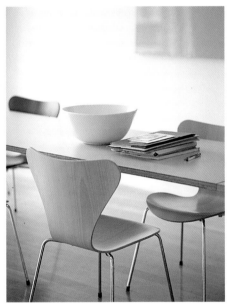

Elizabeth Wilhide *with photography by* **Andrew Wood**

WATSON-GUPTILL PUBLICATIONS / NEW YORK

Senior designer Ashley Western
Senior editor Annabel Morgan
Location researcher Kate Brunt
Stylist Sally Conran
Production manager Meryl Silbert
Head of design Gabriella Le Grazie
Publishing director Anne Ryland

Published in The United States in 2000
by Watson-Guptill Publications,
a division of BPI Communications, Inc..
1515 Broadway, New York, N.Y. 10036

First published in 2000
by Ryland Peters & Small,
Cavendish House, 51–55 Mortimer Street,
London W1N 7TD

Library of Congress Catalog Card Number: 99-67359

ISBN 0-8230-3109-8

Manufactured in China
First printing, 2000
1 2 3 4 5 6 7 8 9 / 07 06 05 04 03 02 01 00

CONTENTS

Right *A symmetrical grouping of classic Eames chairs is the perfect accompaniment to the spare architectural lines of this loft.*
Below *Alvar Aalto's stacking stool has a timeless modernity that means it is at home in any interior.*

Introduction

As Le Corbusier pointed out, the chair is essentially defined by its primary function: it is something to sit on, "a machine for sitting on" in his precise words. A chair must support the body in at least one and preferably several seating postures and it must do so without breaking or tipping over. It is an added bonus if the chair is comfortable, and equally advantageous from a purely practical standpoint if it is easy to manufacture, economical in its use of material, and hence affordable.

But chairs are never merely defined by their functional roles, and they never have been. The throne and the bench are both machines for sitting on, in Le Corbusier's sense, but their forms express very different meanings. A chair can be a power seat, a command post, a spatial marker, a status symbol, a vehicle for decoration, a statement of artistic intent. At least some of these roles are embedded in language: "chairman" or "chairperson" being a case in point.

Over the last century, the chair has been the subject of particularly intense experimentation. Superficially, much of this exploration could be seen as an attempt to reconcile the form of the chair with advances in materials technology and manufacturing processes. Yet if we examine the variety of ways designers have responded to the chair's form, it is obvious that other factors are also coming into play.

The chair is one of the most anthropomorphic of furniture types. In its traditional form, it has a back, a seat, arms and legs; occasionally elbows, knees, and feet. It sits up, and even unoccupied, its presence in a space is more evocative than the presence of a table or chest of drawers. This almost human quality may explain why, given the choice, people tend to have their favorites, preferences dictated not exclusively by comfort or a perfect physical fit. It may also explain why very different chairs can appear quite natural grouped together in the same room, rather like a gathering of people.

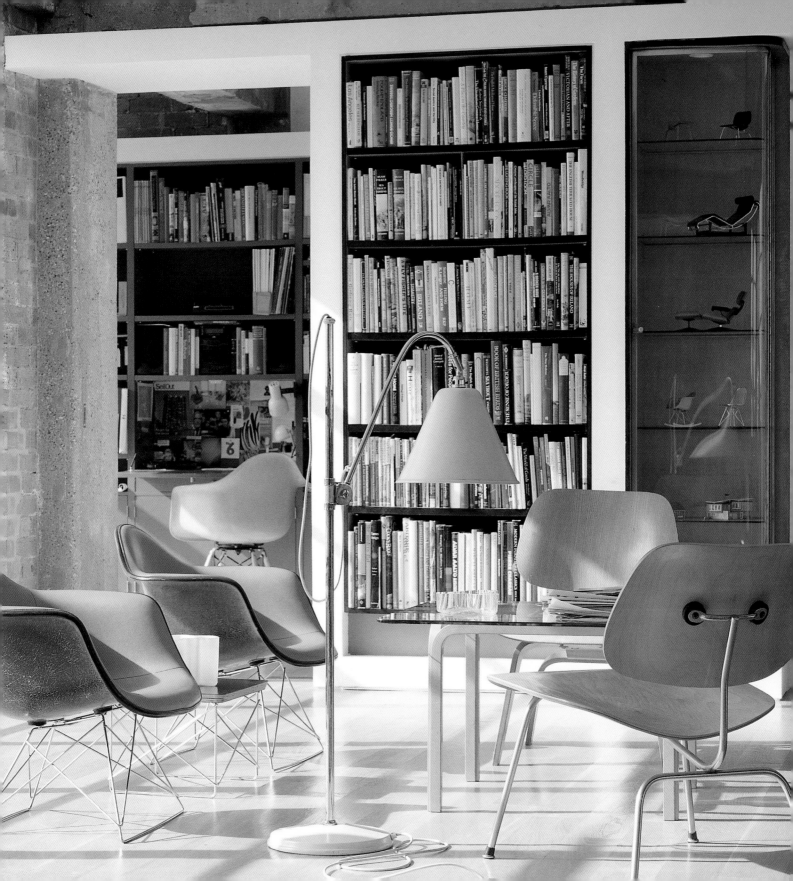

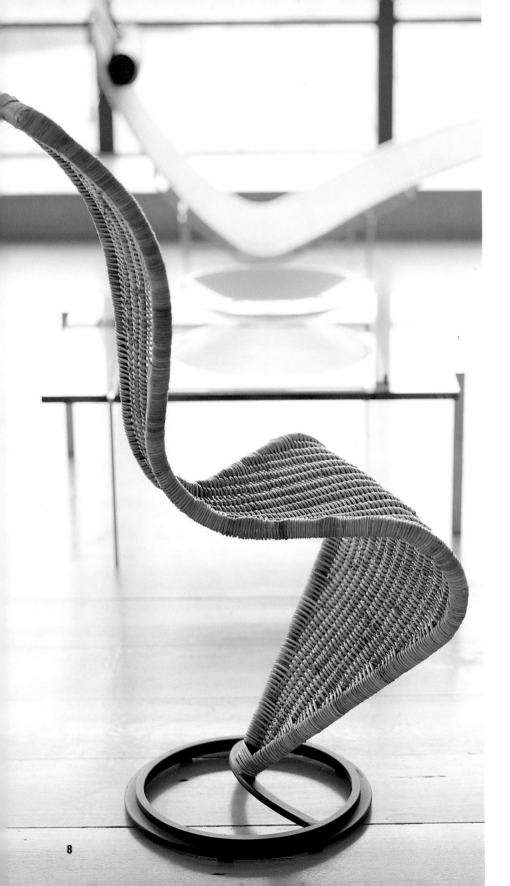

At the same time, chairs have always been designed to be looked at as much as sat upon. Carved, inlaid, painted, or decorated with precious materials, chairs have provided the means to display the highest degree of workmanship and finesse. Even at their most simplified, they can be both sculptural and expressive—highly sophisticated compositional exercises. Within the necessary practical constraints, designers have found they can say almost anything with the form of the chair.

"When we design a chair, we design a society and a city in miniature" wrote British architect Peter Smithson (*The Cantilever Chair*, 1986), a statement that encapsulates the ambitious agenda of many twentieth-century designers. The attraction of the chair as a design exercise is that it offers the designer the opportunity to summarize his or her principles, to make a case for a way of looking at the world. It is no surprise that architects are often designers of chairs as well. Many architects, of course, like to control how their buildings are furnished, but they also have found the chair to be an important way of stating their beliefs. In this way, Rietveld's Red/Blue chair reveals the design program of De Stijl, while, as Smithson says, "the Miesian city is implicit in the Mies chair."

The principles of the early modernists were enshrined in the familiar mantra "form follows function." The modernist chair, as "machine," both satisfied its functional roles as concisely as possible and attempted to make use (although not always successfully) of the most economical and efficient industrial materials and manufacturing methods. In this idiom we find the first experiments with cantilever chairs made of tubular steel and, later, exploitations of new materials such as bent plywood, injection-molded polypropylene, and plastic. Something about the invention of a new material seems to inspire designers to make a chair out of it.

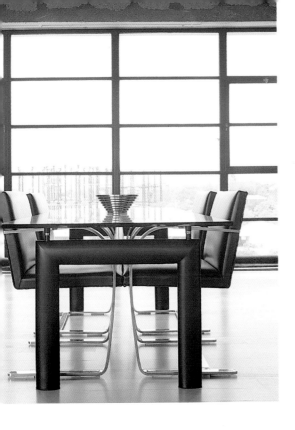

However, a chair need not be technically innovative to be original. Jacobsen's Egg chair, which cradles the body in a womblike shell, is not particularly inventive in terms of material or manufacturing, but it achieves an almost poetic form. The minimalism of Jasper Morrison's open-backed Ply chair, a reworking of a traditional form, reinvents the wheel in one sense, but in another achieves something quite new in its refinement and modern sensibility. Bertoia's Diamond chair, crafted from welded steel mesh, asks how light, how airy a chair can be. Aalto's stool, whose simple design is based on a refinement of a jointing technique, is absolutely "right."

The chairs in this book have been selected first and foremost because they have stood the test of time—or seem set to do so. More extreme or provocative examples could have been chosen, chairs that challenge the very idea of what a chair can be—chairs made of glass, out of recycled car seats, or in the form of outsized leather baseball gloves. But the chairs in this selection are notable in that, almost without exception, they were recognized as significant departures—classics—from day one, even if such critical acclaim did not immediately translate into commercial success. A few of these chairs have sold millions, some have remained in continuous production since they were first designed and marketed and, today, all are in current manufacture.

A design classic has been defined as one "which visually or by association sums up the best of its time, and yet whose appeal has surpassed its immediate historical context" (*Thames and Hudson Dictionary of Twentieth Century Design and Designers*). But it is not only designers who are to be applauded when "classic" status is attained. Credit is also due to those manufacturers who had the foresight and commitment to put the designs into production, companies like Knoll, Artek, Vitra, and Cassina, who have taken great care to make sure the individual designer's intentions are met and have jealously guarded details of manufacture to preserve the vital elements of originality. In a few cases, protection of an idea has proved impossible against the tide of market forces; some of the chairs featured in this book are best known in the form of unlicensed copies.

Ultimately, however, the chairs in this selection are those that successive generations have wanted to use and own, which means that they have managed to satisfy both aesthetic and functional requirements to some significant degree. While not all, strictly speaking, are comfortable, comfort is never entirely ignored: these designs make more than a little accommodation to the human form—they bend, give, and support even when they do not swaddle or enclose. Nor are they merely amusing one-liners, good for defining a decade's preoccupations and little else. True modern classics are designs for living.

Opposite *The sinuous, sensual curve of Tom Dixon's S chair clearly reveals the designer's sculptural preoccupations.* **Left** *Designed in 1929, the Brno chair by Mies van der Rohe is a supremely elegant essay in the cantilevered form.* **Below** *New materials have inspired new forms for the chair in the twentieth century. Frank Gehry's Wiggle chair is constructed from layered cardboard, while Coray's Landi chair is made from aluminum.*

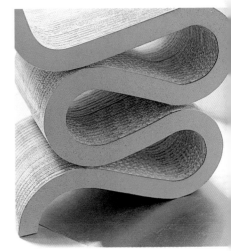

ALVAR
AALTO 1898–1976

Born in a small rural Finnish town, Alvar Aalto studied architecture in Helsinki from 1916–21 and set up his own practice in 1923. The following year he married Aino Marsio, an architect, who subsequently collaborated with him on many of his projects. Another key figure was Otto Korhonen, a craftsman-carpenter with whom Aalto set up a furniture workshop in Turku in 1927. Aalto first received international recognition for the sanitorium he designed at Paimio (1929-33); his revolutionary use of bent plywood, as displayed in the Paimio chairs, also captured world interest when they were displayed at exhibitions in London, Paris, and New York.

Many of Aalto's furniture designs were conceived for his buildings, including the library at Viipuri (1927-35) and the student quarters at MIT, Boston (1947-49), but their universal quality has given them enduring popularity. In 1935 Aalto and his wife, together with Harry and Marie Gullichsen, founded Artek, a retail outlet that continues to sell many Aalto designs, from furniture to lights, textiles, and glassware. Although essentially a modernist, Aalto never neglected the human qualities of ease and comfort. One of the best-known Finns of the twentieth century, his portrait is featured on his country's banknotes. Aalto was awarded the Gold Medal by the Royal Institute of British Architects (RIBA) in 1957.

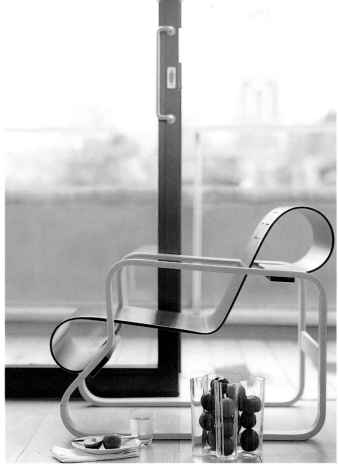

Paimio chair, model no. 41 (1931–32)

Manufacturer: Artek

The Paimio was the first important design to emerge from Aalto and Korhonen's experiments with bentwood techniques. While influenced by the elegant form of the German and Dutch modernists' tubular steel chairs, the Paimio displays a distinctly un-modernist use of wood: Aalto often found machine-age design lacking in "human qualities." Mies van der Rohe apparently attributed Aalto's preference for wood to the fact that he lived "deep in a forest."

The chair caused a considerable stir when exhibited at Fortnum and Mason in London in 1933. The seat and back are formed from a single piece of laminated curved birch ply, hung within a bentwood frame of solid birch. Like most of Aalto's work, the chair is both comfortable and economical to produce in large numbers.

Opposite and this page The scrolled curves of the Paimio, achieved in laminated plywood, marry modernism with the more humane qualities of Scandinavian design. The sleek, organic form of the chair is dramatically revealed in silhouette *(above right)*.

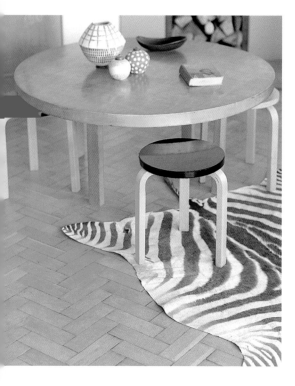

Stool, model no. 60 (1932–33)

Manufacturer: Artek

Designed for the Viipuri Library, this stacking stool is perhaps the best known of all Aalto's works. Widely imitated, the stool remains hugely popular today, being used just as often as a side table as an occasional seat.

The stool makes use of the bent "L" leg devised by Korhonen and Aalto in their early experiments with bentwood; Aalto later compared the "L" leg's significance as a design element to the Greek column. This basic component, economical to manufacture in large numbers, is a feature of many of Aalto's later designs. Made of solid wood, the "L" legs are joined directly to the seat, which is available in different finishes.

Armchair, model no. 406 (1938–39)

Manufacturer: Artek

Aalto's work won international recognition at many exhibitions, including the 1937 Paris Exhibition. This chair is a variation of the chaise longue he designed for the Finnish Pavilion at the Paris show.

The bent birch frame of the chair supports a seat and back made of fabric webbing, a feature that would subsequently become characteristic of many Scandinavian designs. The basic clarity of the form is married to an almost organic quality; Finland's landscape had a lasting influence on Aalto's work. Aalto's affection for natural materials was partly inspired by William Morris and others in the Arts and Crafts Movement.

Top left, below left Virtually unimprovable, Aalto's stacking stool is a true modern classic. At home in every room, it serves equally well as a side table or an occasional seat.
Bottom right, opposite The webbed fabric back of Armchair 39 reveals Aalto's affection for natural materials and gives the piece an easygoing informality.

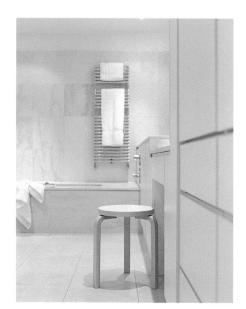

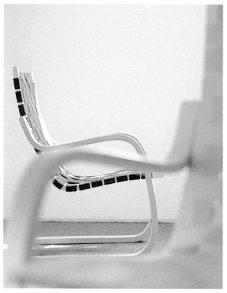

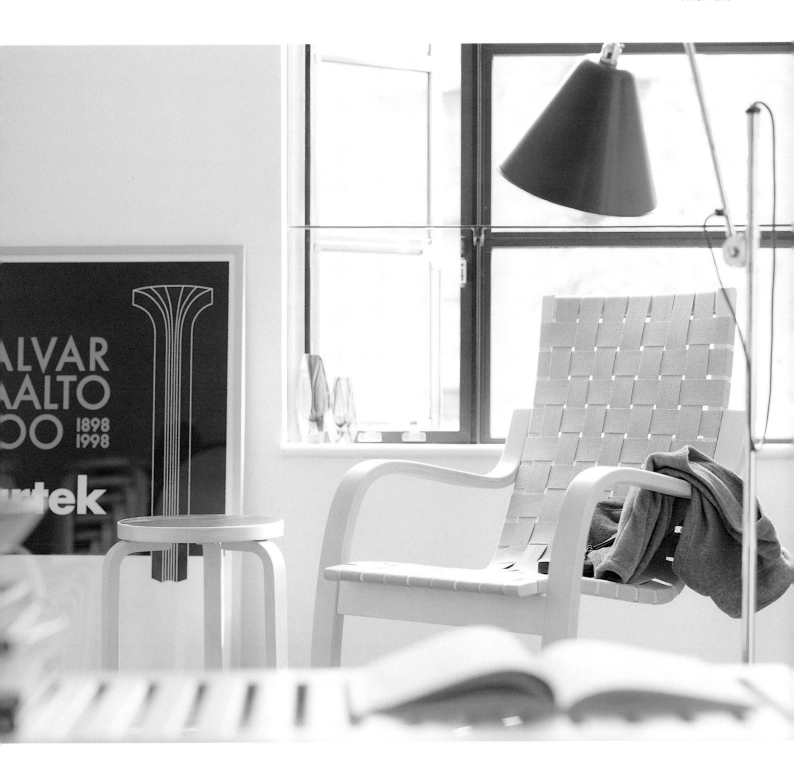

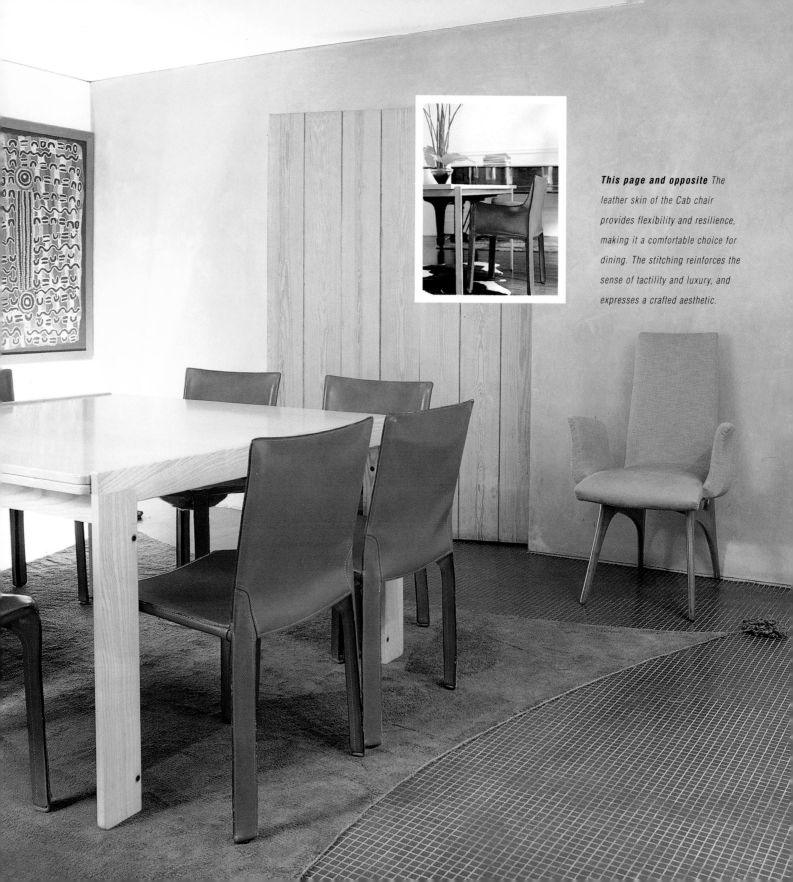

This page and opposite The leather skin of the Cab chair provides flexibility and resilience, making it a comfortable choice for dining. The stitching reinforces the sense of tactility and luxury, and expresses a crafted aesthetic.

MARIO BELLINI b.1935

One of Italy's leading designers of the postwar period, Mario Bellini was born in Milan and studied architecture at Milan Polytechnic, graduating in 1959. He taught and set up his own studio before joining Olivetti as a consultant designer in 1963. Perhaps best known for his innovative designs for office machines, he has also worked with many other well-known Italian companies, including Cassina, Artemide, Flos, and FIAT, on products as diverse as lights, car interiors, office chairs, and tables. Bellini's special contribution to Italian design can be seen in the sculptural sophistication of the Lettera 10 portable typewriter (1976–77), the Lexikon 83 typewriter (1976), and the ET 101 electronic typewriter, all of which display his characteristically elegant reconciliation of function and form.

For Bellini, ergonomics and practicality are only starting points for his designs: "I try to give things a value, a content beyond simple appearance." From 1986 to 1991 he was editor-in-chief of the influential Italian design and architectural magazine *Domus*. Several of his designs are included in the Permanent Collection in the Museum of Modern Art, New York.

Cab chair, model no. 412 (1977)
Manufacturer: Cassina

Simple yet expressive, Bellini's Cab chair represents an original and evocative twist on a basic form. As in many of Bellini's designs, a hint of anthropromorphism is included along with the clarity of the design. The underlying frame (or skeleton) of the Cab chair is made of enameled steel; the covering (or skin) is saddle-stitched leather that zips up the sides. The polished leather skin makes the chair appealingly tactile and at the same time serves as the means of supporting the body in comfort.

The luxurious material and high degree of detailing give what is essentially a manufactured product a more handcrafted appeal; the zippered covering adds a touch of exoticism. The design is also available as an armchair or couch; colors are white, tan, and black.

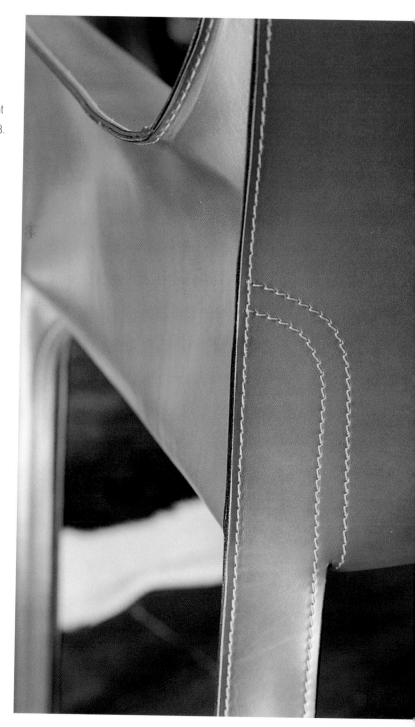

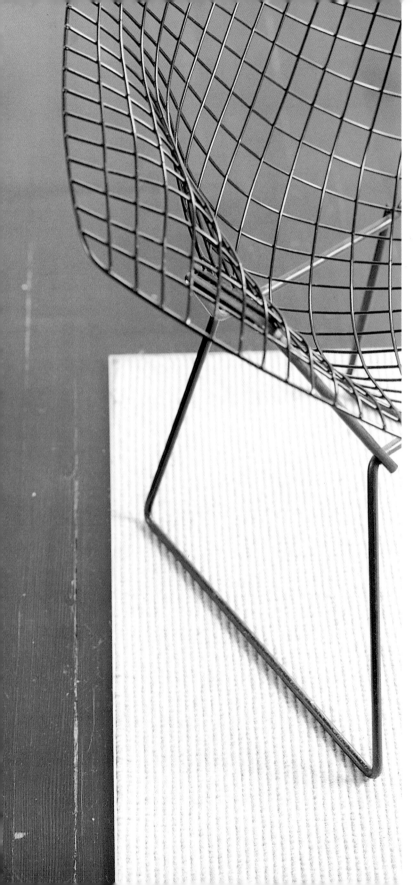

HARRY
BERTOIA 1915–1978

Born in Undine, Italy, Harry Bertoia emigrated to the United States in 1930. A contemporary of Charles Eames and the Knolls, he studied at the Cranbrook Academy of Art, Michigan, before setting up its metalworking department.

Bertoia always resisted the term "designer" and preferred to think of himself as a sculptor, being particularly concerned with "space, form, and the characteristics of metals." In 1943, after Cranbrook, Bertoia went to work in California on the development of molded plywood technology, collaborating with Charles and Ray Eames on designs for plywood chairs. He left their studio in 1946 amid rumors of a rift, reportedly feeling that his contribution had been unacknowledged.

In 1950 Knoll helped Bertoia set up his own studio, and his most famous design, the Diamond chair, was produced soon after. Bertoia went on to win "Designer of the Year" in 1955 but his principal interest remained what he termed "scultural thinking," conveying a sense of lightness and airiness in form. Bertoia's eventual return to sculpture was funded by the huge financial success of his wire chairs.

Diamond chair (1950–52)
Manufacturer: Knoll

The Diamond chair is the perfect expression of Bertoia's "sculptural thinking." Describing his chairs as "studies in space, form and metal too," he adds they "are mostly made of air...space passes right through them." In the design of this chair, Bertoia drew on his wartime experience in the manufacture of glider parts. "I wanted my chair to rotate, change with movement." The diamond mesh is an essay on transparency, the grid spaced as widely as possible to admit light without weakening or distorting the overall form.

The frame, made of welded steel rods, is available in polished or satin finish with a weather-resistant vinyl coating. A seat cushion that snaps in place is available, and there is also a fully upholstered version, with an inset padded shell, as well as a larger model. The chair has been in continous production since 1952.

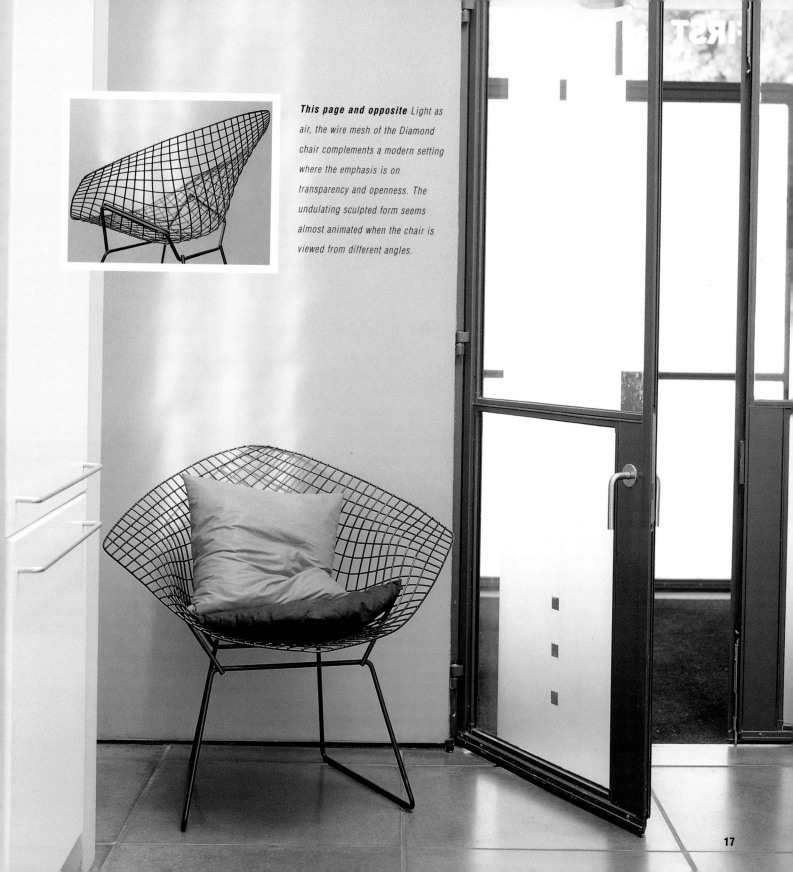

This page and opposite *Light as air, the wire mesh of the Diamond chair complements a modern setting where the emphasis is on transparency and openness. The undulating sculpted form seems almost animated when the chair is viewed from different angles.*

17

MARCEL BREUER 1902–1981

One of the most influential of all twentieth-century furniture designers, Marcel Breuer was born in Pecs, Hungary, and studied art in Vienna before moving to Weimar in 1920 to enroll at the Bauhaus. There he studied furniture design under Walter Gropius, and soon demonstrated his brilliance and originality. When the Bauhaus moved to Dessau in 1925, Breuer was asked to design furniture for the masters' houses and other buildings on the site. The famous Wassily chair dates from that time, with the B32 or Cesca, his cantilever chair, following a year later. Breuer left the Bauhaus in 1926 to set up an architectural practice in Berlin.

With the worsening political climate in Europe, Breuer, who had Jewish parents, moved first to Switzerland and then to Britain, where he joined Gropius in 1935. Although he produced molded plywood designs for the Isokon company and won a few architectural commissions, it soon became clear to Breuer that modernism was going to remain a minority enthusiasm in Britain. Breuer consequently followed Gropius to the United States, where they practiced architecture and taught together at Harvard School of Architecture, influencing a whole new generation of designers. In later years, Breuer's own house at New Canaan, Connecticut (1951), became a place of pilgrimage for those devoted to progressive ideals.

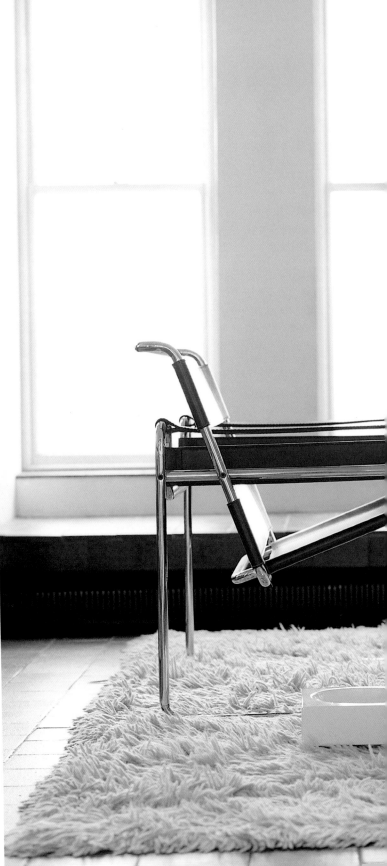

Wassily chair, model no. B3 (1925)

Manufacturer: Knoll

This revolutionary chair is named after the painter Wassily Kandinsky, for whose quarters at Dessau it was originally designed. In later years, Breuer maintained that he first got the idea for using tubular steel in furniture design from his beloved Adler bicycle, whose stength and lightness impressed him so much. The Wassily chair, a reworking of the traditional club chair form, clearly reveals the influence of the Dutch modernists, notably Rietveld, in its arrangement of bisecting horizontal and vertical planes.

The fluid, gleaming horizontals of the tubular steel frame support slings of fabric, canvas, or more usually leather, carefully arranged so the body never comes into contact with cold metal. The Wassily chair remained prohibitively expensive until it was mass-produced in the 1950s and 1960s. It has since become one of the defining classics of modernist design.

Cesca chair, chair B32 (1926)

Manufacturer: Knoll, from 1968

Perhaps the best known and most popular of all cantilever designs, the B32, as it was originally known, was designed while Breuer was still teaching at the Dessau Bauhaus. Sharing many of the characteristics of the tubular steel cantilever chairs of Mart Stam *(see page 69)* and Mies van der Rohe *(see page 50)*, Cesca's elegant exploitation of the potential of a new industrial material marks it as a turning point in twentieth-century design.

The B32 chair was originally manufactured by Standard-Möbel and subsequently by Thonet, Gallina, and, most recently, Knoll. When the design was revived in 1960, it was renamed the Cesca after Breuer's daughter, Francesca. The simple, light, chrome-plated tubular steel frame supports a seat and back of comfortably yielding woven cane on bent frames of solid beech.

Opposite, far left, above bottom Cesca's springy cantilevered seat makes it a popular choice for a dining chair.
Left, above top Wassily's taut lines look as modern today as they did when the chair was designed in 1925.

HANS
CORAY b.1907

Born in Zurich, Hans Coray's early career was devoted to figurative art. The Landi chair, his best-known design, did not appear until 1939. Although this outstanding success was followed by a number of other furniture designs in the 1950s, in later life Coray once again returned to fine art.

The Landi premiered at the *Schweizerische Landesausstellung*, the Swiss national exhibition of 1939, where it met with immediate critical approval. The design had been commissioned by Hans Fischli, the exhibition's director, who wanted a chair that could be used both indoors and out. The interruption of World War II meant that the chair did not reach an international audience until the 1950s, but it has remained in continous production ever since. The design represents a clever application of materials technology, and with the advent of the hi-tech aesthetic in the 1970s, the popularity of the Landi received another boost. The OMK stacking chair, by British designer Rodney Kinsman, is an obvious descendant of this seminal design.

Landi chair (1938)

Manufacturer: Zanotta

Lightness, strength, and durability are the hallmarks of this design. The Landi chair represents Coray's imaginative response to the development of heat-tempered aluminum alloys at the end of the 1930s, resulting in exciting new materials that were as just as hard, resilient, and strong as steel. Aluminum always had the advantage of lightness; but until the heat-tempering process was devised, it remained a relatively weak material. The regularly spaced rows of bold punched holes that form such a graphic feature of this design serve to enhance the chair's basic quality of lightness: the Landi weighs only seven pounds.

The back and seat of the Landi are manufactured from a single sheet of aluminum. The sheet is molded into shape in a press and then perforated before the legs are screwed on. A whitening solution applied to the metal gives the finish its pristine appearance.

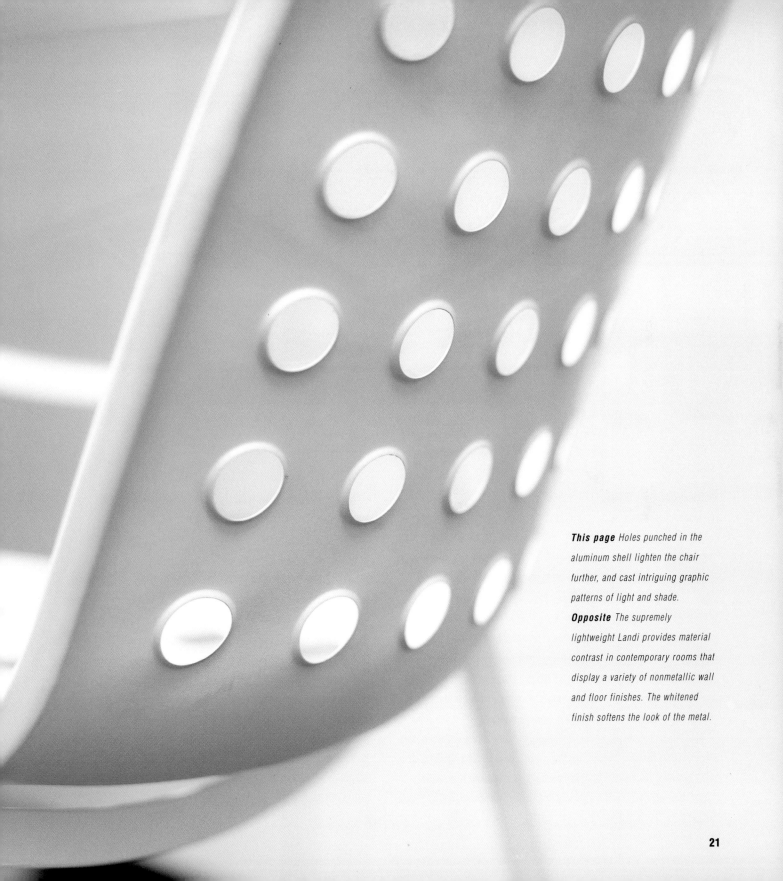

This page Holes punched in the
aluminum shell lighten the chair
further, and cast intriguing graphic
patterns of light and shade.
Opposite The supremely
lightweight Landi provides material
contrast in contemporary rooms that
display a variety of nonmetallic wall
and floor finishes. The whitened
finish softens the look of the metal.

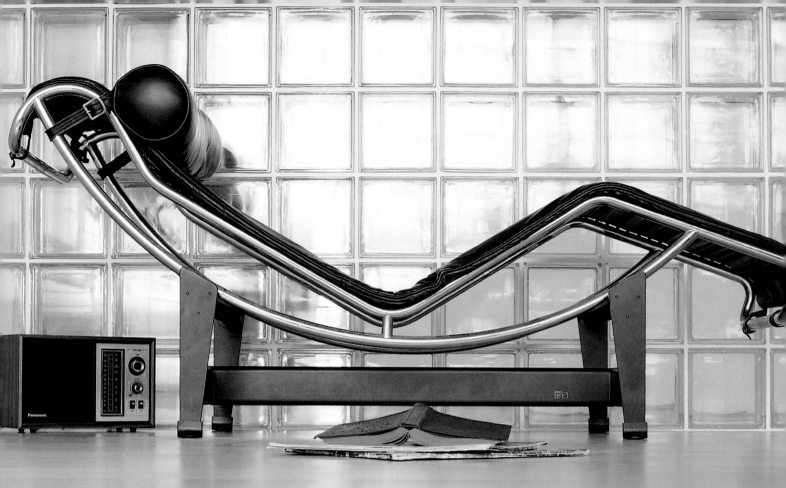

Chaise longue B306 (1928)

Manufacturer: Cassina from 1965

"The house is a machine for living in....An armchair is a machine for sitting in..." wrote Le Corbusier in *Towards a New Architecture*, 1923. Corbusier's functional approach to furniture arose out of his search for universal solutions to design problems. Leather club chairs and Thonet's mass-produced bentwood chairs were two such solutions that he particularly admired, and they both featured in the interior of the pavilion he designed for the Paris Exhibition of 1925. The chaise longue B306 is a descendant of the Thonet rocker, and one of the earliest examples of ergonomic design.

The adjustable seat, covered in leather, pony skin, or fabric, has tubular steel runners resting on the rubber-cushioned crossbars of a black-painted iron base. The chair was first shown at the Salon d'Automne, Paris, in 1929 and was originally manufactured by Thonet.

Grand Confort armchair (petite modèle) (1928)

Manufacturer: Cassina from 1965

Le Corbusier intended that all of his furniture designs should be mass-produced and hence affordable, but difficulties associated with their manufacture meant that such pieces often remained prohibitively expensive. This armchair, like the chaise longue, was shown at the Salon d'Automne in 1929 and was originally manufactured by Thonet.

The revolutionary aspect of this superbly rational design is the exposure of the tubular steel framework, a functional and defiantly honest statement which in no way compromises comfort. The metal framework holds loose upholstered cushions covered in leather; webbing supports the seat. The cushions are foam-filled but were originally stuffed with down; the framework can be chrome- or nickel-plated or lacquered, as in the original design. Sofa versions of the armchair design are also available.

LE CORBUSIER 1887–1965 and CHARLOTTE PERRIAND b.1903

One of the towering figures of modern architecture, Le Corbusier (Charles-Edouard Jeanneret) revolutionized twentieth-century notions of spatial design, from the planning of cities to the conception of the interior. Born in Switzerland, he trained initially as a metal engraver, but was drawn to the architectural potential offered by new techniques of mass production and materials such as reinforced concrete. At the center of an artistic avant-garde in Paris in the early 1920s, he attempted to formulate a universal language of form that could be applied to buildings, a theory later put into practice in some of the most seminal works of the century, including the Villa Savoye outside Paris (1929–30), the Unite d'Habitation in Marseilles (1947–52), and Notre Dame-du-Haut at Ronchamp (1950–54).

Most of Corbusier's famous furniture designs date from a period in the late 1920s and early 1930s, and were the result of a collaboration between Corbusier, his cousin Pierre Jeanneret (1896–1967), and Charlotte Perriand, who joined the studio in 1927 and left ten years later. Perriand had already experimented with tubular steel in interior design, but her critical role in the creation of these great classics was largely unacknowledged until recent years. In the 1980s she advised the manufacturer Cassina on the techniques employed to make the original pieces.

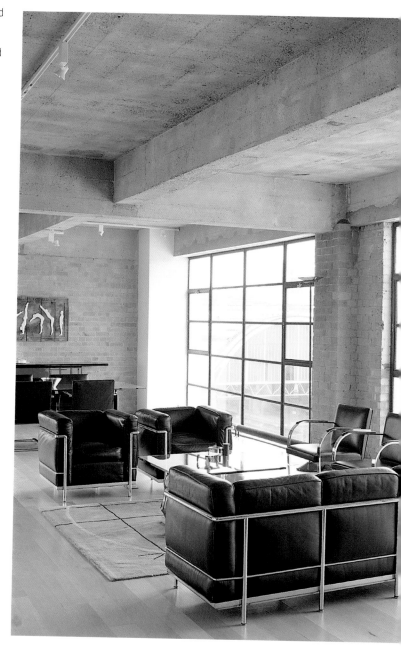

Opposite One of the most elegant of all chaise longues, the flowing lines and sinuous curves of this famous recliner echo the supine form of the human body in repose. **This page** In either sofa or armchair versions, the boxy design of the Grand Confort lends itself to symmetrical arrangements. The deep, leather-clad cushions clasped within the understated metal framework completely transformed the concept of upholstered furniture.

ROBIN
DAY b.1915

The acclaimed British designer Robin Day was born in High Wycombe and studied at the Royal College of Art, London, from 1934 to 1938, where he met his future wife, Lucienne, the celebrated fabric designer. Together, the couple came to epitomize the progressive spirit of postwar British design.

The early part of Day's career was devoted to graphic and exhibition design. An opportunity to move into furniture came in 1949 when Day, in collaboration with Clive Latimer, won a competition organized by the Museum of Modern Art in New York to design low-cost furniture. Their winning design, for a modular storage system made of tapered plywood and tubular aluminum, was just the beginning of a lifetime's interest in "designing things that most people can afford." As a direct result, Day was asked to design for the London furniture manufacturer, Hille, an association that was to last 20 years.

International recognition came in 1951, when Robin and Lucienne Day collaborated on the design of two rooms at the *Homes & Gardens* pavilion at the Festival of Britain. Day's long career has included a variety of major public commissions, including the seating for London's Royal Festival Hall, as well as designs for radios and televisions and aircraft interiors.

This page The basic Polyprop chair is available in a variety of different formats and a dazzling choice of colors. Its low cost and ease of stacking *(opposite page)* have made it a popular choice in utilitarian as well as domestic settings. A recent adaptation of the design is available in pale translucent plastic.

Polypropylene chair (1963)

Manufacturer: Hille

Hugely popular and widely copied, the Polyprop is a chair that most people have encountered at one time or another—in school auditoria, doctors' waiting rooms, or anywhere else cheap, reliable, stackable seating is required. Estimates vary, but between 14 and 40 million are said to have been sold in 23 countries around the world. The first chair to make use of injection-molded polypropylene (invented in 1953), its economy derives from the fact that a single tool can make 4,000 seats a week. Robin Day launched the chair by sending 600 free samples to architects, designers, and journalists.

The base is made of chrome-plated bent tubular steel, while the lightweight shell has a deep curved lip to provide rigidity. Produced in a variety of bright colors, it also comes in an "armchair" version (designed in 1965), which has been recently revived by Tom Dixon at Habitat using the original Hille molds.

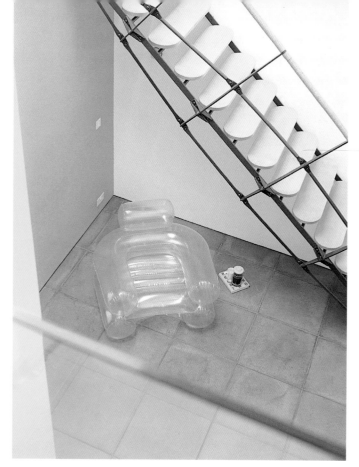

DE PAS, D'URBINO, LOMAZZI, and SCOLARI

Jonathan De Pas, Donato D'Urbino, Paolo Lomazzi, and Carla Scolari (all born in the 1930s and trained at Milan Polytechnic) set up a design practice in 1966 in Milan. Influenced by Ettore Sottsass, who was himself inspired by the early 1960s British Pop movement in design, the group was one of a number of Milan-based practices that set out to deliberately challenge the prevailing values of modernism, particularly its rationale as a fundamental expression of manufacturing processes and exigencies. Such disposable, "fun," and witty "anti-designs" as the Blow chair, which this group produced in 1967, and the Sacco bean bag (designed by Gatti, Paolini, and Teodoro in 1968), captured the spirit of the age, a period that also gave the world such design ephemera as the paper minidress.

The group went on to design a series of inflatable structures for the Italian pavilion at the 1970 Osaka World Fair. Also in 1970, they produced the Joe armchair—a chair in the form of an overscaled leather baseball glove. The group has since specialized in adaptable furniture design and produced work for manufacturers such as Zanotta, Driade, and Stilnovo.

Blow chair (1967)

Manufacturer: Zanotta

The original, and best, version of the inflatable chair, Blow has become an icon of pop culture. The first-ever completely inflatable piece of furniture to be mass-produced, the design was immediately popular when it first appeared in Italy, and inspired many imitations. Literally deflating the importance of the chair as a designed object, Blow is made of welded vinyl; the design was made possible by new heat-sealing techniques. It is available in a choice of transparent colors and is light enough to be used in a swimming pool—a suitably irreverent pop location.

The recent revival of interest in 1960s design has seen a proliferation of designs for inflatable furniture and furnishings, from Blow-inspired chairs to cushions, eggcups, and picture frames.

This page and opposite
Irreverent and humorous, the Blow chair debunks the status of the modern designer chair. Inflatable design, a feature of the 1960s Pop movement, has seen a revival of interest in recent times.

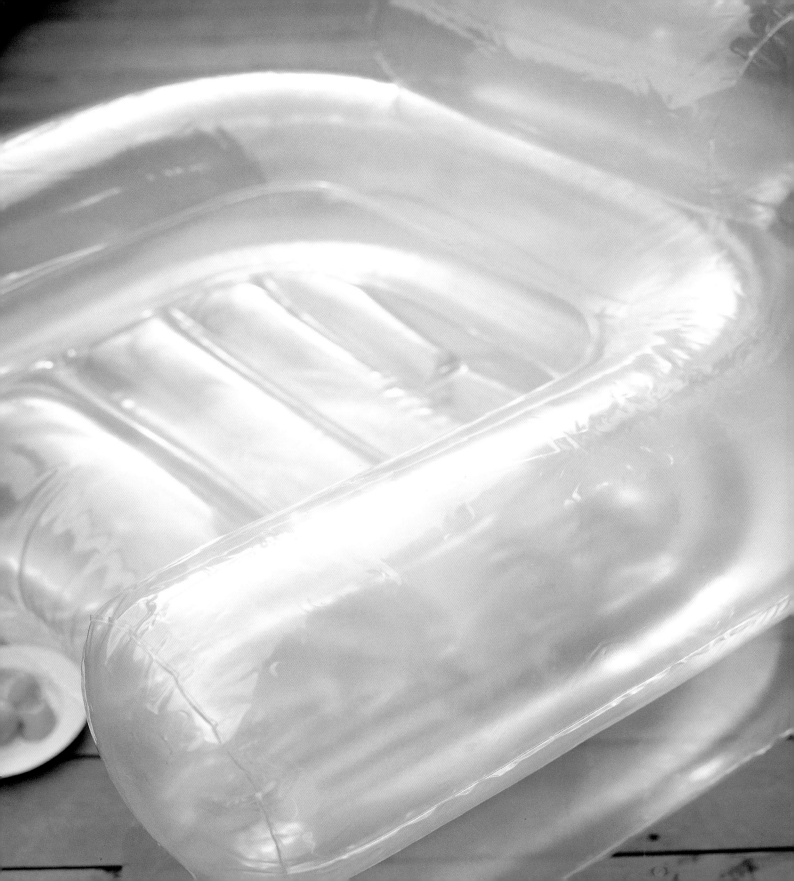

TOM
DIXON b.1959

The son of a schoolteacher, Tom Dixon was born in Tunisia, returned to Britain with his family at the age of four, and grew up in Huddersfield and London. An early interest in art and design led him to study at St. Martin's College of Art, London, but he dropped out after six months, finding the requirement to specialize for degree work not to his liking. In the early 1980s he set up Creative Salvage with other ex-students and began producing one-off pieces of welded furniture incorporating salvaged railings, pots and pans, and tubing.

The S chair dates from the second phase of his career, when he left Creative Salvage to set up Space, a company and store selling furniture and lighting designed by himself and other contemporaries. Jack, a molded polyethylene seat that doubles as a source of illumination, was as commercially successful as the S chair and dates from 1996. In the same year, Dixon sold Space and set up Eurolounge, which produces designs in plastic. In 1998 Dixon became Design Director of Habitat, a position that will enable him to fulfill a long-term aim—to produce affordable high-quality design for the ordinary home.

This page and opposite The S chair appears to be on tiptoe, frozen in motion. It may look more like a sculpture than a chair, but the S is surprisingly supportive, despite its cantilevered seat and tiny waist.

S Chair (1988)

Manufacturer: Cappellini, from 1992

With its sinuous, snakelike curves, the S chair was the first of Dixon's designs to receive widespread attention and acclaim. Its expressive shape and sculptural quality heralded the introduction of a new aesthetic in British design. Like his earlier welded metal furniture, the chair's design owes its particular quality to the fact that it arose out of a sculptural process rather than a drawing.

The chair consists of a welded steel frame, ending in a circular foot, and covered in woven wicker or rush. Alternative versions in latex rubber or upholstery are also being produced. The cantilever form, with its tiny waist, swelling seat, and minimal backrest, is as much sculpture as design, while the tactile woven covering evokes organic and primitive associations.

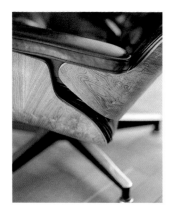

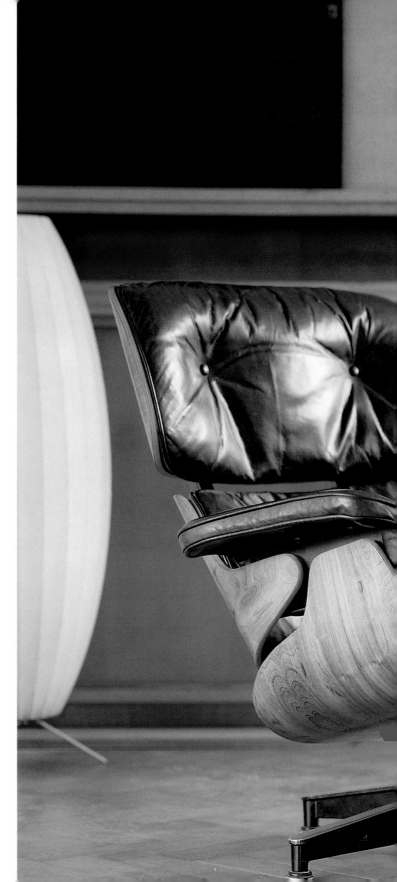

Left It may be almost half a century old, but the Eames lounge chair with its sleek and glossy finish possesses a timeless modernity that suits any location. **Right** The Eames Lounger has a magisterial presence that speaks of power and importance, but the sheer comfort of the leather-clad chair and stool also creates an atmosphere of luxury and relaxation.

CHARLES AND RAY
EAMES 1907–1978
and 1912–1988

The husband-and-wife partnership of Charles and Ray Eames was one of the most successful and influential creative collaborations of the twentieth century. They met in the late 1930s at the Cranbrook Academy of Art in Bloomfield Hills, Michigan, where Charles had been invited to head the department of experimental design by Eliel Saarinen. Charles, born in St. Louis, trained initially as an architect; Ray Kaiser was an artist studying weaving. Following their marriage in 1941 they moved to California and set up their own practice in 1944. Their house, built in 1949 in Pacific Palisades, made radical and colorful use of prefabricated elements.

At Cranbrook Charles had collaborated with Eero Saarinen (*see page 64*), son of Eliel, on a number of furniture designs in molded plywood that won first prize in a competition at the Museum of Modern Art in New York in 1940. Subsequently Charles, among others, researched the use of this material for the U.S. Navy in wartime projects. After the war, Eames was invited to put on a one-man show at MOMA in 1946; the show featured a series of molded plywood chairs—designs that made the Eames's international reputation and led to their hugely successful collaboration with the progressive furniture company Herman Miller. The following decades witnessed the production of a wide range of innovative designs in a number of materials, including fiberglass, wire, and aluminum, creating a whole new vocabulary of mass-produced modernism.

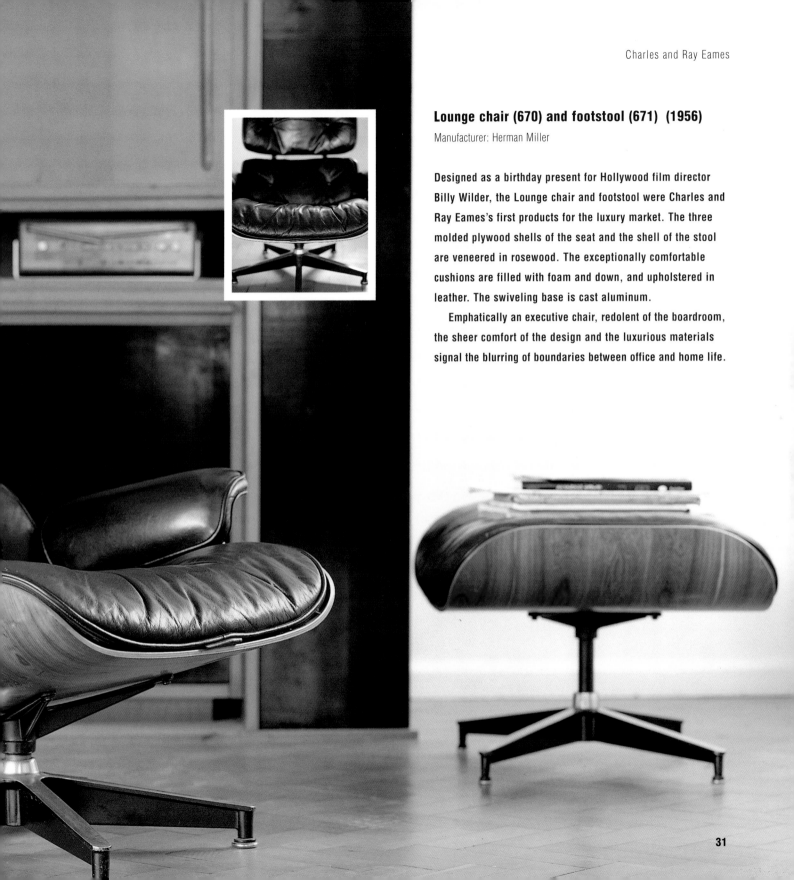

Lounge chair (670) and footstool (671) (1956)

Manufacturer: Herman Miller

Designed as a birthday present for Hollywood film director Billy Wilder, the Lounge chair and footstool were Charles and Ray Eames's first products for the luxury market. The three molded plywood shells of the seat and the shell of the stool are veneered in rosewood. The exceptionally comfortable cushions are filled with foam and down, and upholstered in leather. The swiveling base is cast aluminum.

Emphatically an executive chair, redolent of the boardroom, the sheer comfort of the design and the luxurious materials signal the blurring of boundaries between office and home life.

DCM (1946)

Manufacturer: Herman Miller

This page and opposite *The DCM and LCW are at ease in almost any location in the home. The smooth wood finish of the seat shells adds comfort and tactility. The DCM, with its slender metal frame, is more upright than the low-level LCW, as befits a dining chair.*

A great modern classic, the DCM (dining chair metal) is one of a series of molded plywood chairs that dates from the mid-1940s. Exhibited at MOMA in 1946 and subsequently put into production by Herman Miller, the DCM was an instant success, both critically and commercially. The molded plywood seat and back are attached to a chrome-plated tubular steel frame with rubber shock-mounts glued to the wood to provide give and flexibility. These points of attachment were the result of long practical and aesthetic experimentation. Versions of this design were produced with three legs, but proved to be too unstable and were therefore never put into production.

LCW (1946)

Manufacturer: Herman Miller

Like the DCM, the LCW (lounge chair wood) was born of the prolonged period of experimentation with molded plywood that Charles Eames had begun back in Michigan in the late 1930s. After Charles and Ray moved to Los Angeles in 1941, they continued to experiment with the material, even constructing their own rather dangerous plywood molding machine in their apartment. Their original intention—to create a single-shell plywood chair—proved impossible, as the material was not strong enough to withstand stresses at major points. The Eames's wartime projects—making molded plywood leg splints for the U.S. Navy—and Ray's plywood sculptures led to a refinement of their ideas. This chair, unlike others in the series, has a bentwood frame in three parts bolted to a molded seat and back.

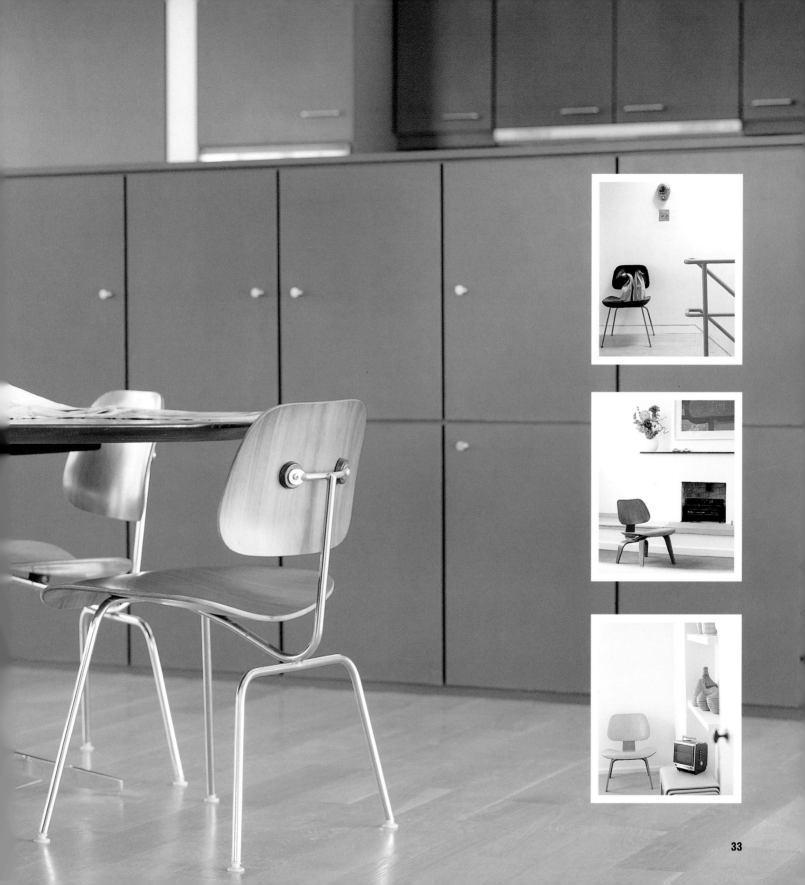

FERRARI-HARDOY, KURCHAN, and BONET

Argentinian designers Jorge Ferrari-Hardoy, Juan Kurchan, and Antonio Bonet were all originally trained as architects and founded their practice in 1935. Their most famous work, the Hardoy chair (also known as the BFK or Butterfly chair), was designed for their own offices, but came to international attention when the director of the Museum of Modern Art in New York, Edgar Kaufman Jr., acquired the first two imported into the United States.

Although the design dates from 1938—and the origins of the basic idea go back much farther—the chair has since come to represent the essence of 1950s style, with its organic shape and fine steel frame. Like the inflatable Blow chair *(see page 26)*, the Hardoy inspired so many copies that the original design could not effectively be protected. Before World War II, the Hardoy was manufactured by Artek-Pascoe; around 1950, Knoll International began to produce the design in a royalty arrangement with Ferrari-Hardoy. The company's attempt to prevent unlicensed copies from flooding the market failed, and the design, with all its variations, has become to all intents and purposes generic.

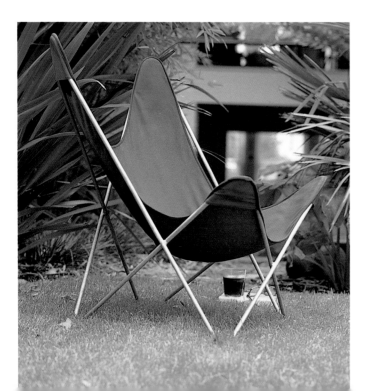

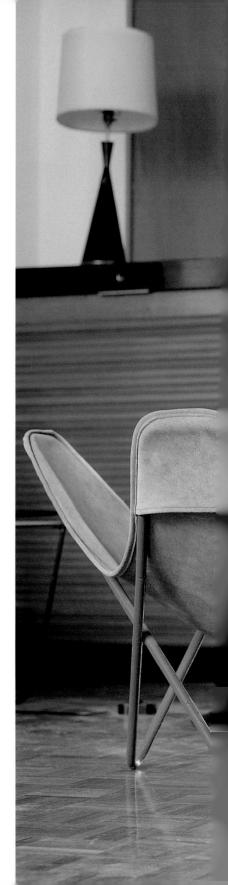

This page and opposite *Like many modern designs, the Butterfly chair is as much at home in outdoor living areas as it is in the interior. The lightweight frame and slung seat make it easy to carry from place to place. A particularly pleasing feature of the design is the dynamic intersecting diagonals of the tubular steel support, which is fashioned from a single length of metal.*

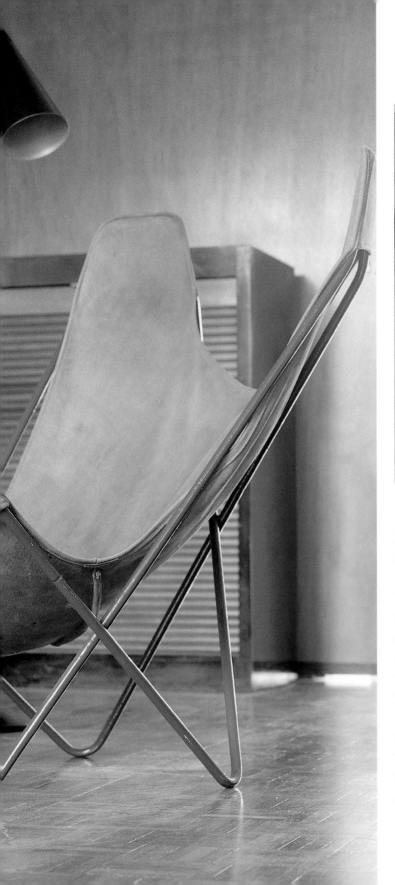

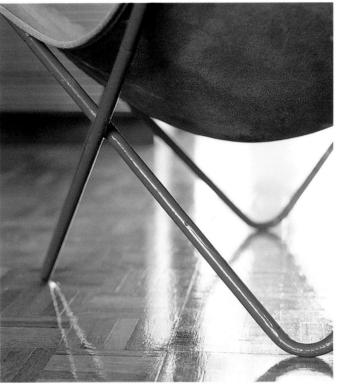

Hardoy chair (BFK chair or Butterfly chair) (1938)

Manufacturer: reissued by Stohr Import-Export GmbH, Germany from 1982

The basic idea for this sling chair derives from a mid-nineteenth century design by British civil engineer Joseph Berkeley Fenby and used by British officers in the field. The original, designed in 1855 and patented in 1877, was later manufactured in Italy during the 1930s under the name "Tripolina" and consisted of a lightweight folding wooden frame with a pocketed canvas sling seat.

The Hardoy brings the concept up to date. The tubular steel support, made from a single length of metal, creates a light, airy framework. The canvas or leather seat, suspended from the frame by means of inverted pockets, has a more exaggerated shape than the Tripolina and anticipates the organic, amebalike forms of postwar design.

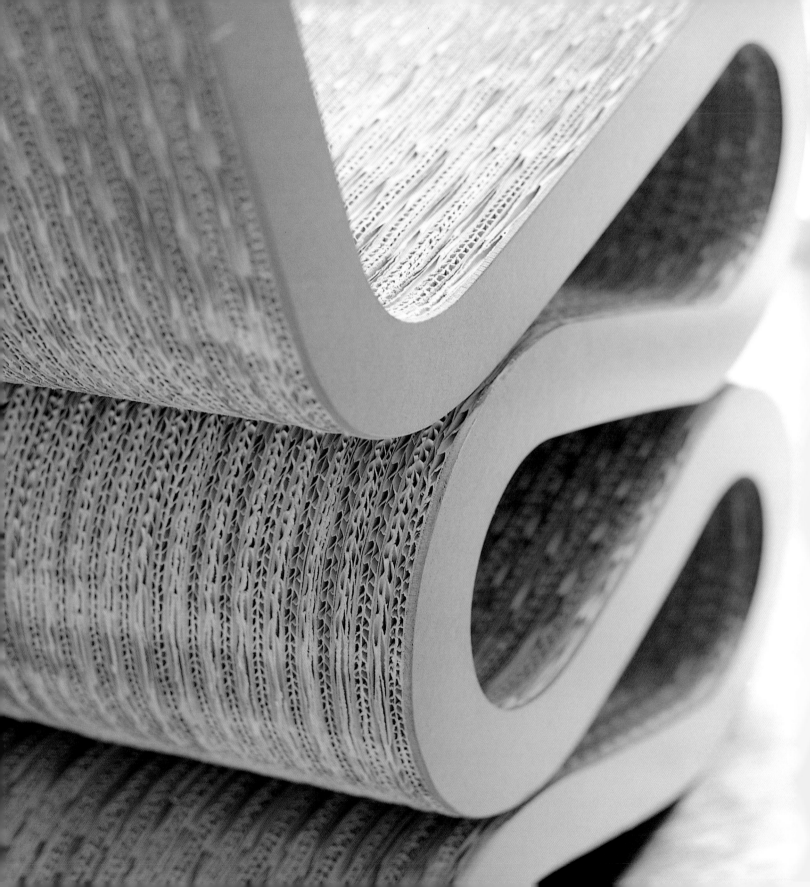

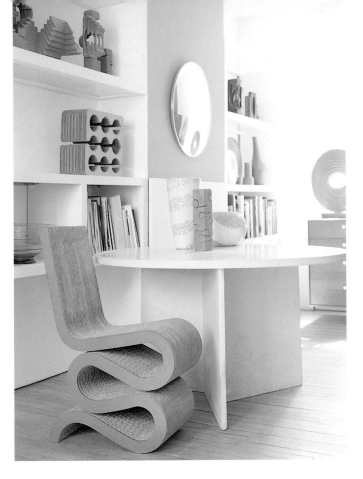

FRANK
O. GEHRY b.1929

Born in Toronto, Canada, in 1929, Frank Gehry studied design and ceramics at USC (the University of Southern California in Los Angeles) between 1949 and 1951, graduating in architecture in 1954. After studying city planning at Harvard Graduate School of Design from 1956 to 1957, and subsequently working as a designer, planner, and architect, he set up his own practice in Los Angeles in 1962.

Many of Gehry's early buildings, including houses and studios in southern California and the Loyola Law School, Los Angeles (1979–80), displayed a post-modernist reworking of historical themes and references. More recent work, including the much-acclaimed Guggenheim Museum in Bilbao and the American Center in Paris, reveals his highly individual and sculptural approach. Like his buildings, many of Gehry's furniture designs show a similar expressiveness and often feature an unusual use of materials. Given his interest in the design of chairs, a particularly appropriate commission was the Vitra Design Museum, Germany, the institute founded by the German manufacturer Vitra, which houses a major international collection of classic chairs.

Wiggle side chair (1972)

Manufacturer: Vitra, from 1992

Wiggle is Gehry's characteristically tongue-in-cheek version of a modern design classic, Gerrit Rietveld's Zigzag chair *(see page 62)*. Much of the humor of the rippling design derives from the fact that this chair is constructed entirely from a supremely disposable modern material—cardboard. The cardboard, however, is used in thick, laminated layers to achieve a look of solidity and permanence and to give the chair strength and resilience. The resulting tactile surface was particularly pleasing to the designer because it "looked like corduroy, it felt like corduroy, it was seductive."

Wiggle is one of a series of fourteen pieces called "Easy Edges." The die-cut construction process that Gehry devised for these pieces meant forms could be free and expressive, and also kept prices low.

Opposite The fat, lazy curves of the Wiggle chair appear almost molten and poured, until on closer inspection it becomes apparent that the chair is constructed from laminated corrugated cardboard.
This page Perhaps more a design for looking at than sitting on, the curvaceous lines of the Wiggle chair provide a bold and pleasing sculptural contrast to strong graphic lines in modern interiors.

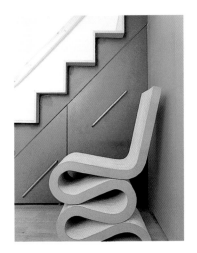

EILEEN
GRAY 1878–1976

Eileen Gray was born in County Wexford, Ireland, into a wealthy and artistic family. She studied at the Slade School of Art, London, in 1898 and then moved to Paris, where she studied drawing, and subsequently lacquerware under the Japanese master Sugawara. Her early work included highly decorative and sophisticated pieces, many in lacquerwork and featuring Oriental motifs. In 1922 she opened Galerie Jean Désert in Paris to sell her own furniture; it was at this period that she began designing interiors as well.

By the late 1920s, the influence of De Stijl and Cubism on her work can be detected in an increasing interest in modernist materials such as tubular steel and in geometric form for both furniture and textile design. In 1926–29, in collaboration with Jean Badovici, the editor of a French architectural journal, Gray designed a vacation house for herself and Badovici at Roquebrune in the south of France. The house, which they named E.1027, was defiantly modernist both in structure and furnishing. Eileen Gray's architectural projects were exhibited in Le Corbusier's pavilion at the 1937 Paris Exhibition, but it was not until many decades later that her full contribution to the development of modern design was truly appreciated.

This page and opposite With its sumptuous white leather upholstery and gleaming metal frame, Bibendum projects luxury and indulgence while at the same time conveying a strong sense of pared-down modernity.

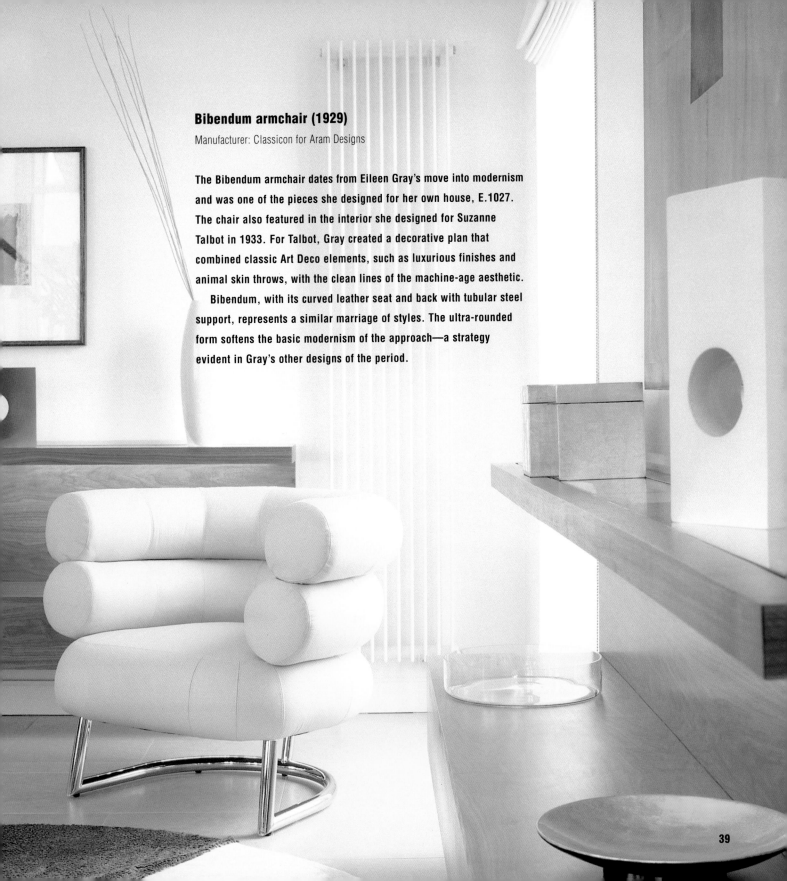

Bibendum armchair (1929)

Manufacturer: Classicon for Aram Designs

The Bibendum armchair dates from Eileen Gray's move into modernism and was one of the pieces she designed for her own house, E.1027. The chair also featured in the interior she designed for Suzanne Talbot in 1933. For Talbot, Gray created a decorative plan that combined classic Art Deco elements, such as luxurious finishes and animal skin throws, with the clean lines of the machine-age aesthetic.

Bibendum, with its curved leather seat and back with tubular steel support, represents a similar marriage of styles. The ultra-rounded form softens the basic modernism of the approach—a strategy evident in Gray's other designs of the period.

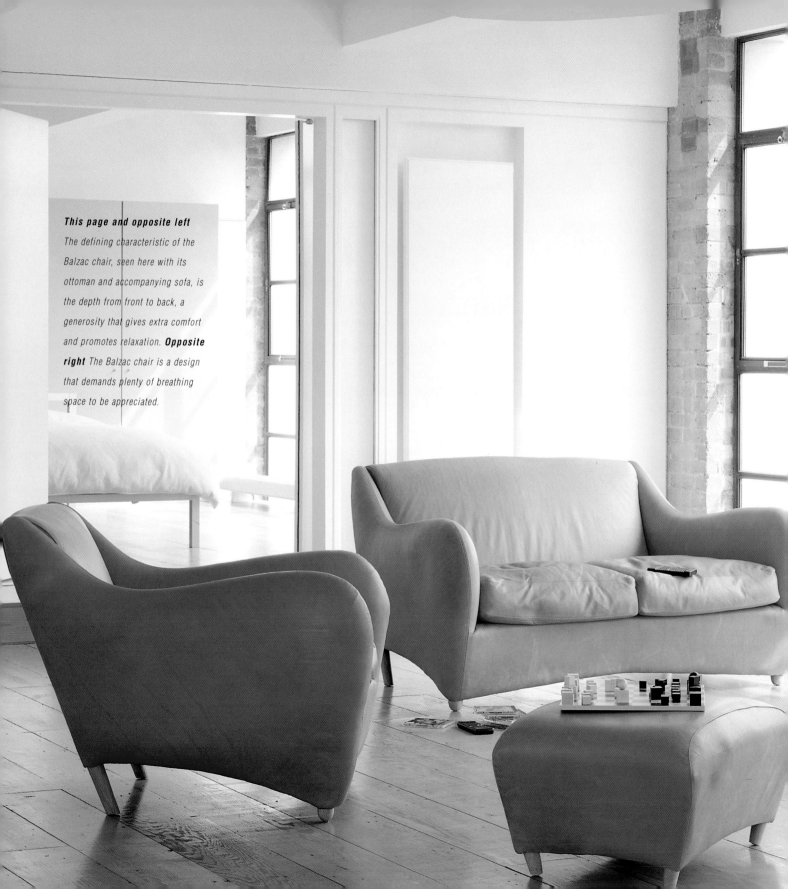

This page and opposite left
The defining characteristic of the
Balzac chair, seen here with its
ottoman and accompanying sofa, is
the depth from front to back, a
generosity that gives extra comfort
and promotes relaxation. **Opposite
right** The Balzac chair is a design
that demands plenty of breathing
space to be appreciated.

MATTHEW HILTON b.1957

Matthew Hilton, one of a new generation of British designers to receive international recognition, was educated at Kingston Polytechnic, where he took a degree in furniture and three-dimensional design. After graduating in 1979, Hilton worked for four years for an industrial design company. A modernist by training and background, Hilton nevertheless stresses the importance of a more human quality in design, which takes into account how furniture is actually used, instead of relying solely on received ergonomic theory.

Hilton's first furniture collection, launched at the Milan Furniture Fair in 1986, included Bow shelves, his first design to be put into production. Manufactured and sold by British furniture company SCP, it marked the beginning of a creative partnership with the firm's director, Sheridan Coakley. Designs for tables, chairs, chests, and beds have followed, many of which are also made and sold by SCP. Several of his pieces are permanently exhibited in the Victoria and Albert Museum.

Balzac chair (1991)

Manufacturer: SCP

Balzac's characteristically deep rounded shape arose out of Hilton's observations of the way people actually sit in chairs—rarely upright and erect, but more often lolling or slouching when relaxing, reading, listening to music, or watching television. The basic idea coincided with Sheridan Coakley's desire to produce an updated version of the club chair. The Balzac allows one to sit right back within its enclosing confines; "the shape and position of the arms came from where I felt one's arms would want to be," says Hilton.

The Balzac chair has a beech frame thickly padded with multidensity furnishing foam, upholstered in natural or black leather, with feather cushions and tapered, rounded oak legs. A similarly curvaceous matching ottoman is available, and there is also a two- and three-seat sofa version of the design.

ARNE JACOBSEN 1902–1971

One of the leading figures of modern Danish design, Arne Jacobsen was born in Copenhagen and initially trained as a mason before studying architecture at the Royal Danish Academy of Arts. Influenced by modernists such as Le Corbusier and Mies van der Rohe, he established his own architectural office in 1930. In 1950, in collaboration with the Danish manufacturer Fritz Hansen, he began to produce designs for a wide variety of products, from furniture, lighting, and textiles to tableware and ceramics, designs which reflected his view that buildings and the furnishings they contained should be conceived as an integrated whole. This approach achieved its finest expression in the design of St. Catherine's College, Oxford (1960-64), and the Royal SAS Hotel, Copenhagen (1958).

Jacobsen's work displays the functional logic of modernism and mass production allied to a more organic aesthetic that is reminisicent of the work of Charles and Ray Eames and traditional craft-based Scandinavian design. But the expressive sophistication of his famous designs, such as the Ant, Swan, Egg, and Series 7 chairs, has a unique clarity that is entirely his own.

3107 chair (1955)

Manufacturer: Fritz Hansen

The most widely imitated of contemporary chairs, the light, stackable 3107 chair is one of the Series 7 designs that won the Grand Prix at the 1957 Milan Triennale. Jacobsen's thorough understanding and appreciation of mass production techniques is evident in the form of the seat, which is made from a single piece of molded plywood. The base of the chair is constructed from chrome-plated bent tubular steel. The original 3107 was available in teak and other wood veneers, but a wide range of bright colors was later added. Other versions of the design have arms, or arms and castors.

With its sinuous curves and obvious waist, the chair suggests the female form, an association that is emphasized in the famous photograph of Christine Keeler sitting astride it.

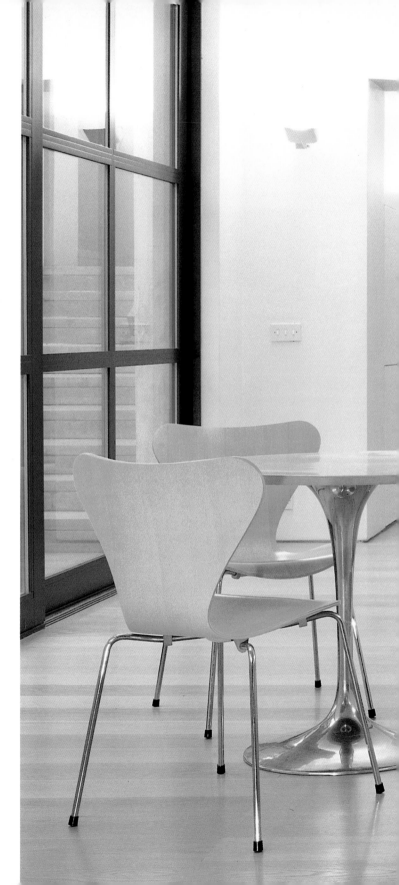

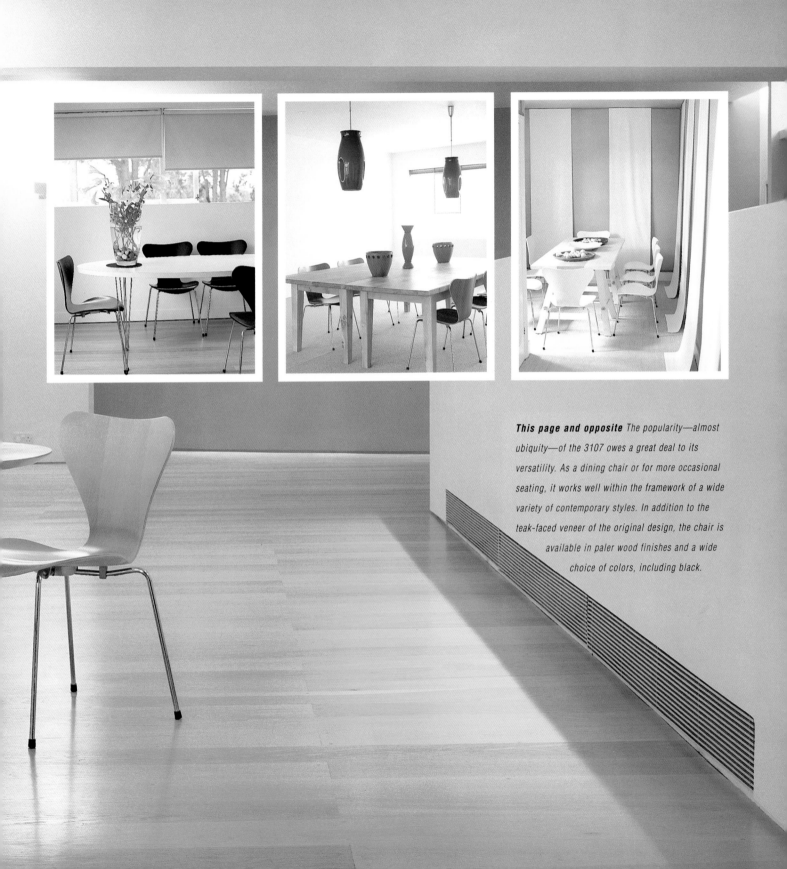

This page and opposite The popularity—almost ubiquity—of the 3107 owes a great deal to its versatility. As a dining chair or for more occasional seating, it works well within the framework of a wide variety of contemporary styles. In addition to the teak-faced veneer of the original design, the chair is available in paler wood finishes and a wide choice of colors, including black.

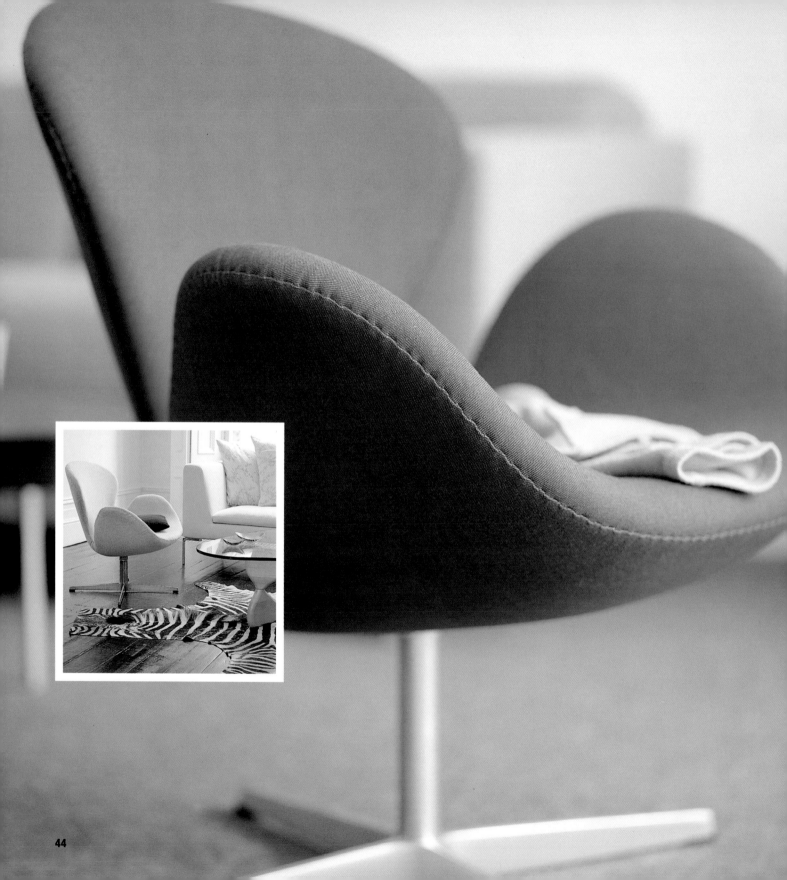

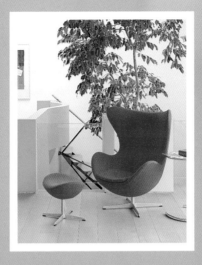

Opposite With its uplifted arms, like a bird's wings, the Swan chair is an elegantly abstracted organic form. *This page.* The curved carapace of Jacobson's Egg chair provides a comforting sense of enclosure for the sitter. Pure and sculptural, the design is a pared-down version of a traditional wing chair.

Egg chair (1957)
Swan chair (1957)

Manufacturer: Fritz Hansen, from 1958

In continuous production for more than forty years, the Egg and Swan chairs were both designed for the lobby of the Royal SAS Hotel, Copenhagen, one of Jacobsen's most important commissions. The project provided him with the opportunity to design not only the building and its interiors, but every element of furnishing, from chairs to flatware to lights to ashtrays, and thus to put into practice his belief in the importance of unity in design.

Both chairs are essays in curves, their smooth, rounded forms providing both a comfortable enclosure and a visual foil for the clean, straight lines of Jacobsen's interiors. Prototypes for the designs were cast in plaster in Jacobsen's garage; the chairs themselves are made of molded fiberglass seat shells mounted on swiveling star bases made of cast aluminum. The Egg chair has a loose seat cushion as well as an accompanying footstool and can be adjusted or tilted to accommodate the user's weight.

In both chairs, the seat shell is covered with foam, which is glued in place and then upholstered in leather, vinyl, or fabric in clear, strong colors. A production difficulty arises from the fact that the upholstery must fit exactly to preserve the purity of shape. While the designs made use of new manufacturing techniques and reflected Jacobsen's commitment to new materials, their originality ultimately derives from Jacobsen's organic, sculptural vision.

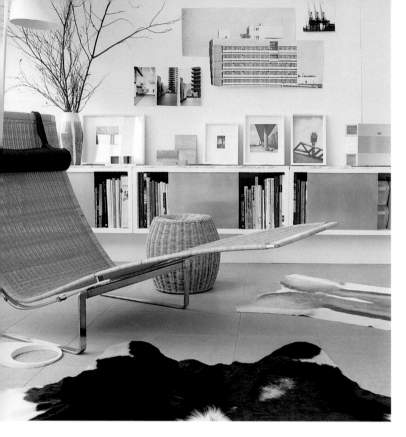

POUL
KJAERHOLM 1929–1980

Born in Oster Vra, Denmark, Poul Kjaerholm studied at Copenhagen's School of
Arts and Crafts, where he subsequently taught in the mid-1950s. From 1955 to
1976, he also taught at the Royal Academy of Arts, Copenhagen. His furniture was
expressly designed for mass-production methods and was manufactured by a
number of firms, including Fritz Hansen and E. Kold Christensen.

Unlike many of his Scandinavian contemporaries, Kjaerholm preferred to use
stainless steel instead of wood as the structural framework for his designs. The
inherent strength and resilience of the steel meant that the structure could be
reduced to the bare minimum. With their obvious origins in the work of
modernists such as Le Corbusier and Mies van der Rohe, Kjaerholm's designs
achieve an elegant purity of form. Kjaerholm's preference for natural materials—
cane, canvas, cord, hide, and skin—for his seats is perhaps more typical of
modern Danish design, but the contrast of metal framework and organic covering
adds depth of character to what would otherwise be rather austere forms.

PK SERIES: Model no. PK22 (1955–56), Hammock no. PK24 (1965), Model no. PK25 (1951)

Manufacturer: Fritz Hansen

Kjaerholm's PK series represents a perfect expression of his refined minimalism and use of intriguing textural contrasts. The Hammock, obviously derived from Le Corbusier's chaise longue *(see page 22)*, has a stainless steel frame covered with woven cane, and a leather headrest. Similarly, the PK 22, reminiscent of Mies's Barcelona chair *(see page 48)*, combines a leather or woven cane seat and back with a flat steel frame. In the case of the PK 25, the effect is more graphic still, with the steel framework contrasted with a seat and back made of flag halyard. With their clean, strong lines and minimal material use, these designs have a lightness of presence: the Hammock has been described as "a diagram of relaxation."

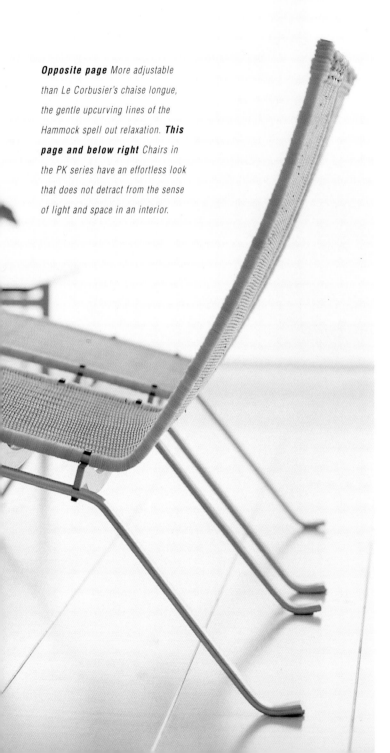

Opposite page More adjustable than Le Corbusier's chaise longue, the gentle upcurving lines of the Hammock spell out relaxation. **This page and below right** Chairs in the PK series have an effortless look that does not detract from the sense of light and space in an interior.

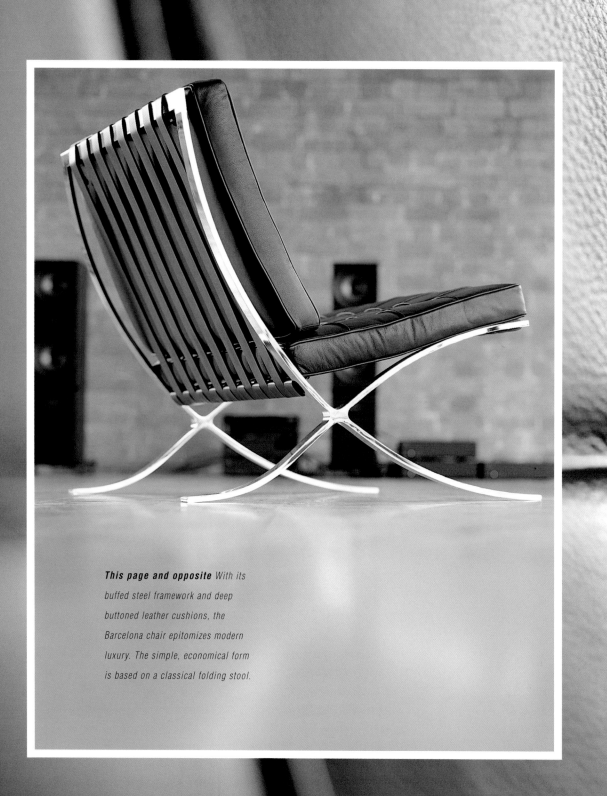

This page and opposite With its buffed steel framework and deep buttoned leather cushions, the Barcelona chair epitomizes modern luxury. The simple, economical form is based on a classical folding stool.

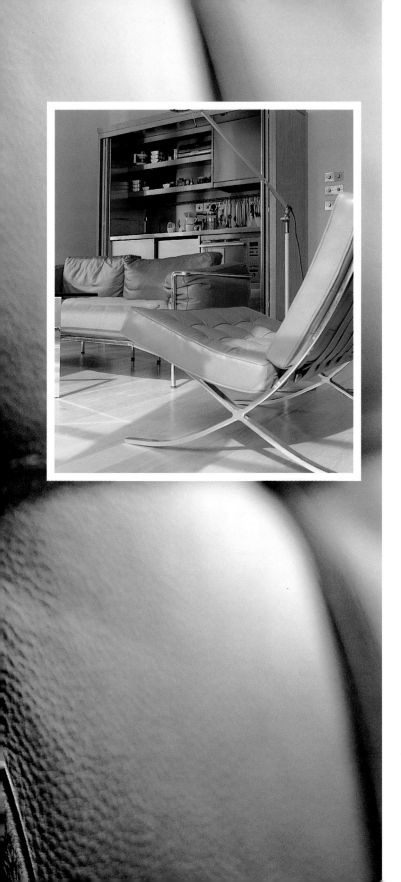

LUDWIG
MIES VAN DER ROHE
1886–1969

Mies van der Rohe was one of the defining figures of twentieth-century design. His beautifully detailed and proportioned furniture as much as his severe, formal buildings in glass and steel have come to epitomize the international style.

Mies was born in Aachen, Germany, and trained as a mason and draftsman before moving to Berlin to study architecture, where he worked first for Bruno Paul and later, from 1908–11, with Peter Behrens. A fervent disciple of modernism, one of his early works was the German pavilion at the 1929 Barcelona Exhibition, with its rigorous use of the grid. Like the pavilion, the Tugendhat House, Brno, Czechoslovakia, which he designed in 1929–30, also featured his own furniture designs. In 1930 Mies became the last director of the Bauhaus, eventually fleeing Germany for the United States in 1938.

Mies taught at the Illinois Institute of Technology, Chicago, and designed several of the campus buildings. Other landmarks include the Farnsworth House, near Chicago (1946–50); apartments on Lake Shore Drive, Chicago (1946–59); and the stunning Seagram Building on Park Avenue, New York (1958).

Barcelona chair, model no. MR90 (1929)
Manufacturer: Knoll

Designed for the German Pavilion at Barcelona and intended specifically as seating for King Alfonso XIII and his queen, the Barcelona chair is based on the design of an ancient classical folding stool. Like many of Mies's furniture designs, the chair was the result of a collaboration with an ex-Bauhaus student, Lilly Reich.

The X frame of the chair was originally made of chromed flat steel, which was hand-finished; today, high-quality stainless steel is used and hand-buffed to a mirror finish. The removable cushions are foam-filled, leather-upholstered, and deep-buttoned; there is also a matching stool. This elegant and beautifully proportioned chair has become a familiar feature of many corporate lobbies.

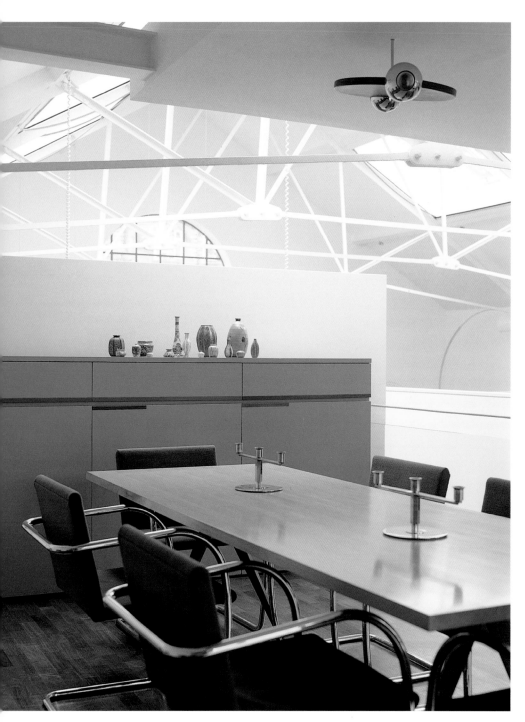

Brno chair (1929)

Manufacturer: Knoll

One of the most refined of all cantilever designs, the Brno was created as a dining chair for the Tugendhat House in Brno. Lilly Reich collaborated with Mies on the design. Comfortable, poised, and with a pleasing clarity, the chair was not Mies's first attempt at a cantilever design, but has since become his best known and most admired. Thanks to a hugely successful marketing campaign by Knoll, the chair became a coveted status symbol in the 1960s and 1970s.

The frame was originally made of chromed flat bar steel, but is now also available in tubular steel. The seat and back upholstery is usually leather, but woven leather, suede, and fabric are also available.

This page and opposite The refinement of the Brno chair has long made it a favorite among design critics. The fluid sweep of the steel frame forms a continuous line and gives the design a pleasing unity.

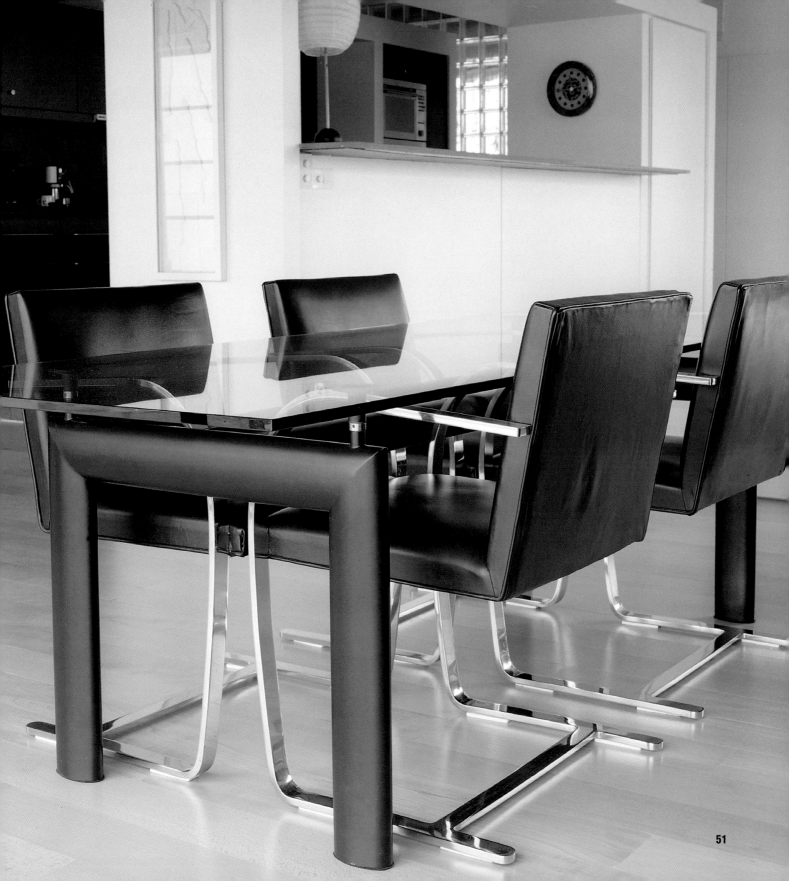

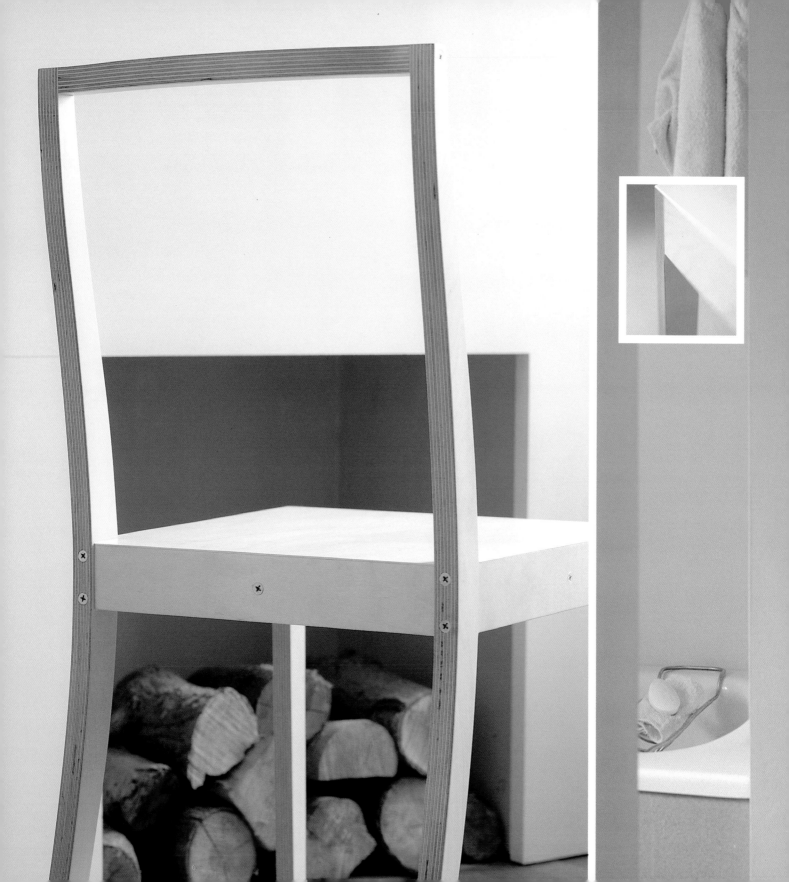

JASPER MORRISON b.1959

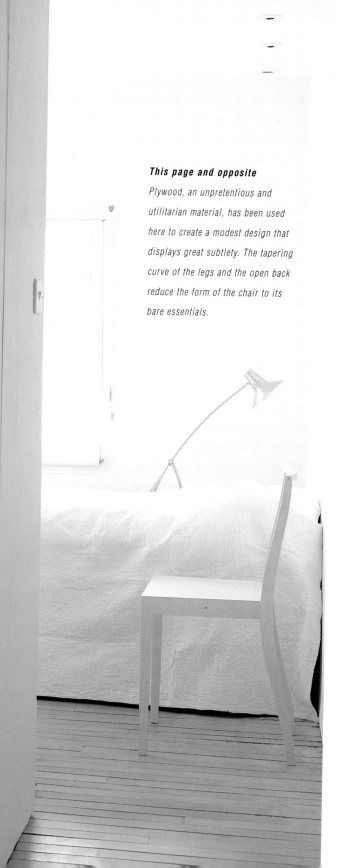

The British product and furniture designer Jasper Morrison studied furniture design at Kingston Polytechnic from 1979 and 1982, then went on to study both at the Royal College of Art in London and the Hochschule fur Kunst in Berlin. Even before his Royal College degree show in 1985, which brought him widespread acclaim and recognition, he had already produced a number of innovative designs, some of which wittily featured recycled components. Hugely influential on a new generation of British designers, Morrison has participated in a number of international exhibitions and designed for leading contemporary manufacturers such as SCP in Britain, the German firm Vitra, and the Italian company Cappellini.

Morrison's work reveals a thoughtful and subtle approach to modernism: simple, practical, and elegant solutions that display a keen awareness of manufacturing techniques and a commitment to affordability. Inexpensive materials such as plywood and aluminum are frequently used in his furniture designs. Other work ranges over a wide field, including a door handle for FSB, a metal and plastic bottle rack for Magis (1994), and a tram for the city of Hanover.

Ply chair (1988)
Manufacturer: Vitra

Morrison sees modernism less as an ideological stance and more as a method, a way of responding to the possibilities offered by different production processes. His contemporary interpretations of the modernist tradition are spare but never austere, and display a 1990s sensibility to qualities beyond appearance and form. His aim is to produce restrained, understated designs, as easy to understand and use and as anonymous as ordinary household objects.

The Ply chair, with its elegantly curved back legs and open back, makes use of one of Morrison's favorite materials. Plywood, both affordable and easy to work with, is also warm and tactile. The chair's seat, which superficially appears unyielding, is comfortable in use, due to the material's essential springiness and resilience.

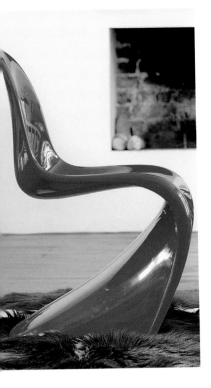

VERNER PANTON 1926–1998

Architect and designer Verner Panton was born in Denmark and educated at the Royal Danish Academy of Fine Arts, Copenhagen, graduating in 1951. After working for a couple of years in Arne Jacobsen's experimental furniture studio, Panton moved to Switzerland and set up his own practice in Binningen in 1955.

Unlike other contemporary Danish and Scandinavian designers, Panton's work betrayed little interest in crafts or natural materials. Best known for his futuristic designs, which exploited the potential of new synthetic materials, Panton developed an aesthetic that was defiantly space-age and ultramodern. A series of chairs designed at the end of the 1950s and beginning of the 1960s combines innovative form with the very latest developments in materials technology. The quirky Heart (1959) was made from sheet metal covered with foam and stretch fabric, while the self-explanatory S (1965) was made from a single bent ribbon of molded plywood. In the latter part of his career, Panton turned his attention to lighting design and also produced designs for textiles. Many of Panton's furniture designs were produced by the Danish firm Fritz Hansen.

Panton chair (1960)

Manufacturer: Vitra for Herman Miller from 1968

Above and opposite Like a vivid smear of lipstick or a car's glossy fender, Panton's stacking chair is an exuberant celebration of modern commercial culture. The sleek sophistication of this plastic chair contrasts with the more organic, natural quality of most modern Scandinavian design.

Panton's most famous design, this plastic stacking chair was also among his most innovative. The first cantilevered design to be made from a single piece of injection-molded plastic, its "look-no-hands" quality represents a daring exploration of material form. Shaped to fit the human frame, the swooping organic curves and glossy finish also recall car bodies, an association emphasized by the finlike sweep of the base, designed to counterbalance the seat.

Like many of Panton's other designs, the chair was originally manufactured by the Danish company Fritz Hansen. Herman Miller took over production in 1968. The prototype was made of GRP, glass-reinforced polyester, but since 1970 the chair has been produced using injection-molded, nonreinforced thermoplastic.

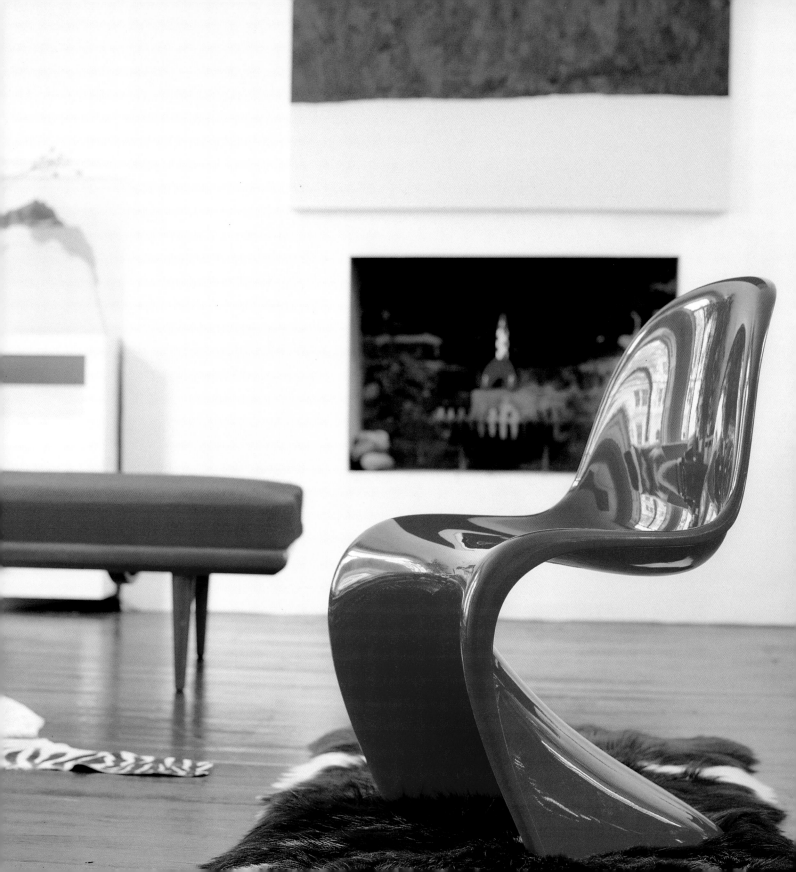

GIANCARLO PIRETTI b.1940

Giancarlo Piretti studied at Bologna's Institute of Art. Ever since he graduated, he has worked for the Italian furniture manufacturer Castelli, eventually becoming the company's director of research and design. Unlike furniture companies which grew out of a craft tradition, as a manufacturer Castelli has been noted for its thorough appreciation of the industrial process. In this context, Piretti's work displays a dedication to ergonomics, ease of production, and affordability: the strength of his designs lies not in their innovative or experimental quality, but in their intelligent resolution of form with the exigencies of the manufacturing process.

While the Plia chair is indisputably Piretti's best-known and most acclaimed design, his other work includes the ergonomic Vertebra office desk chair, which he designed in collaboration with Argentinian-born Emilio Ambasz in 1977, and the Osiris light designed for the German lighting firm Erco.

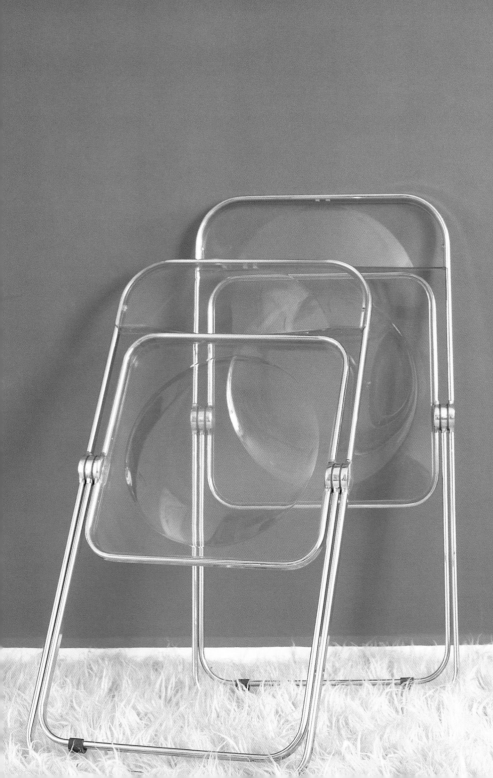

Plia chair (1969)
Manufacturer: Castelli

The Plia is an excellent example of thoughtful design. In form, the chair is based on the traditional wooden folding chair, but the use of modern materials and the subtlety of construction achieve an elegant, almost archetypal solution. Clarity is the defining characteristic of the design, both literally, as in the transparent molded seat and back, and more associatively, in the cleanness of the design. When folded, the chair is only an inch thick, excluding the central portion, and it can also be stacked. The framework is made of chromed steel. Both functional and quietly pleasing, the Plia is a harmonious and versatile design.

Alternative versions of the Plia have been produced with plasticized colored frames and seats in solid polypropylene. The chair has also been made in cane and wood.

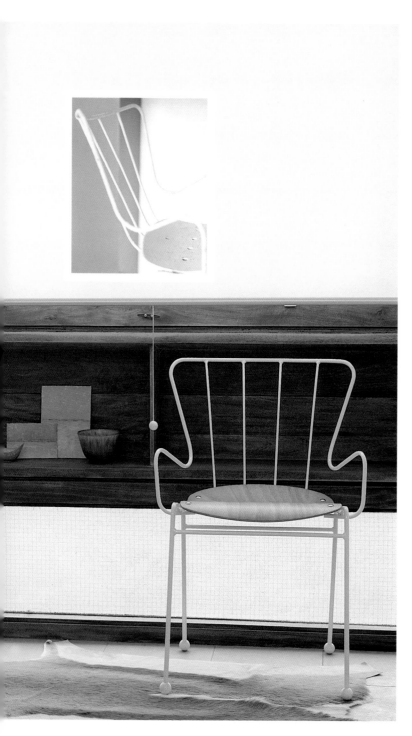

ERNEST
RACE 1913–1964

Born in Newcastle, England, Ernest Race studied interior design at the Bartlett School of Architecture, London, between 1932 and 1935 and subsequently worked as a model-maker and draftsman for the lighting company Troughton and Young. In 1937, after a trip to Madras where his aunt ran a weaving center, he founded Race Fabrics, selling fabric woven in India to his own designs.

Wartime experience in the aircraft industry introduced Race to new developments in materials technology, advances he was quick to apply to furniture design. In 1945 he set up Ernest Race Ltd. with J. W. Noel Jordan to mass-produce low-cost furniture. One of the firm's first products was the award-winning BA Chair (1945), made of cast aluminum alloy. Scrap aluminum, unlike other materials in postwar rationed Britain, was in plentiful supply, and the elegantly detailed chair was highly successful, selling 250,000 during its 23 years in production. A key figure in establishing the "contemporary style" of British design, Race was made a Royal Designer for Industry in 1953.

Antelope chair (1951)

Manufacturer: Race Furniture Ltd.

With its spindly steel rod frame and ball feet, the Antelope chair is a classic 1950s design, echoing the scientific motifs of the period. The atomic age references, however, have more prosaic origins. The minimal use of material reflects the prevailing shortages of rationed Britain immediately after World War II, while the ball feet are designed to protect floors from abrasion from the steel legs. Both the metal frame and molded plywood seat are painted; the seat comes in six colors, including the most popular, red.

The chair was one of two designed by Race for use on the outdoor terraces at the Royal Festival Hall in London and it was exhibited during the year-long Festival of Britain in 1951, where it received maximum public exposure and won much acclaim. The Antelope went on to win a Silver Medal at the Milan Triennale in 1954.

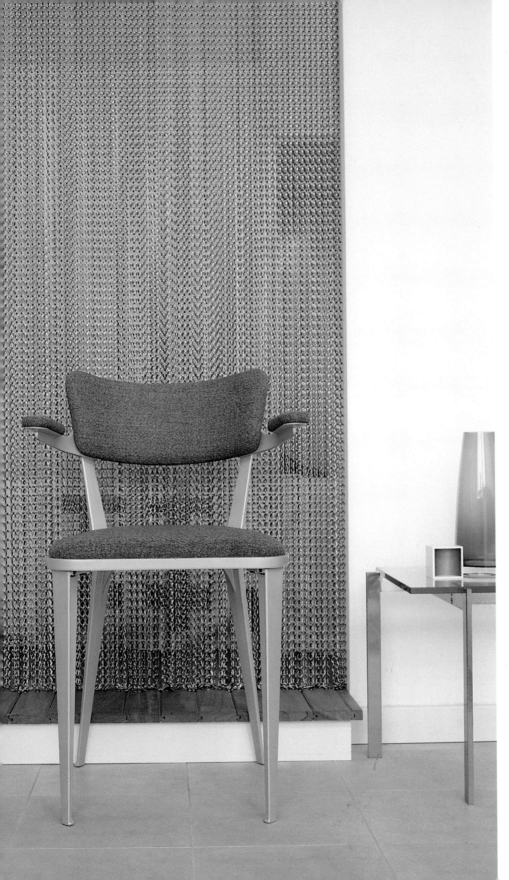

BA chair (1945)

Manufacturer: Race Furniture Ltd

In Britain after World War II, manufacturing and construction materials were in short supply; some were rationed, others simply unavailable. What there was in abundance, however, was scrap aluminum, a by-product of the aeronautical industry. The BA chair, Race's first major success, makes expressive use of this lightweight metal. The elegant, minimal frame, with its tapered legs and high arms, was originally made of sand-blasted aluminum scrap. Upholstery is limited to the seat and back, again a reflection of prevailing fabric shortages. Such economies, however, result in refinement rather than meagerness.

The chair was very innovative for its time and sold in large quantities. It was featured in the postwar exhibition "Britain Can Make It" at the Victoria and Albert Museum in 1946.

This page Making striking use of a salvaged material, the BA was originally made of scrap aluminum. The economy and lightness of the design made it hugely successful.
Opposite page The Antelope chair is unmistakably a 1950s design, with its minimal frame and ball feet—a perfect accompaniment to the long, low lines of contemporary decor

CHARLES RENNIE
MACKINTOSH 1868–1928

Scotland's most famous architect, Charles Rennie Mackintosh was born in Glasgow, the city that would be the site of his greatest architectural achievements. Considered one of the forerunners of modernism, Mackintosh had a distinctive vision that also embraced elements of Art Nouveau. After his apprenticeship, he studied at the Glasgow School of Art before going to work for a local firm, Honeyman and Keppie, in 1889. In 1896 he won the commission to design new premises for the Glasgow Art School, generally regarded as his masterwork, and the same year began a fruitful association with Miss Cranston, proprietor of successful Glasgow tea rooms. Many of his most famous furniture designs were created for her enterprises. Domestic work included The Hill House (1902–04), built for the Blackie family. Mackintosh's wife, the artist Margaret Macdonald, was his lifelong collaborator in interior schemes and decoration.

Mackintosh's design career was short-lived. Misunderstood in his native country, he left Glasgow in 1914 for self-imposed exile in England and later the south of France. Unable to secure substantial architectural work, Mackintosh largely devoted the rest of his life to watercolor painting.

Ingram high-back chair (1900)

Manufacturer: Cassina

Mackintosh designed over 400 objects in his career, from flatware to chairs, light fixtures to textiles. Many were "one-offs" created for a specific context. None were ever put into mass production during his lifetime. The chairs he designed for Miss Cranston's chain of tea rooms were often manufactured by a local firm, Guthrie and Wells.

This exceptionally high-backed chair was designed for the White Dining Room at the Ingram Street Tea Rooms in Glasgow, one of Miss Cranston's ventures. Made of dark-stained oak, it served as a graphic punctuation point in an all-white scheme. The height encloses the diner and provides a sense of intimacy. The squares that pierce the back slats are a characteristic Mackintosh motif.

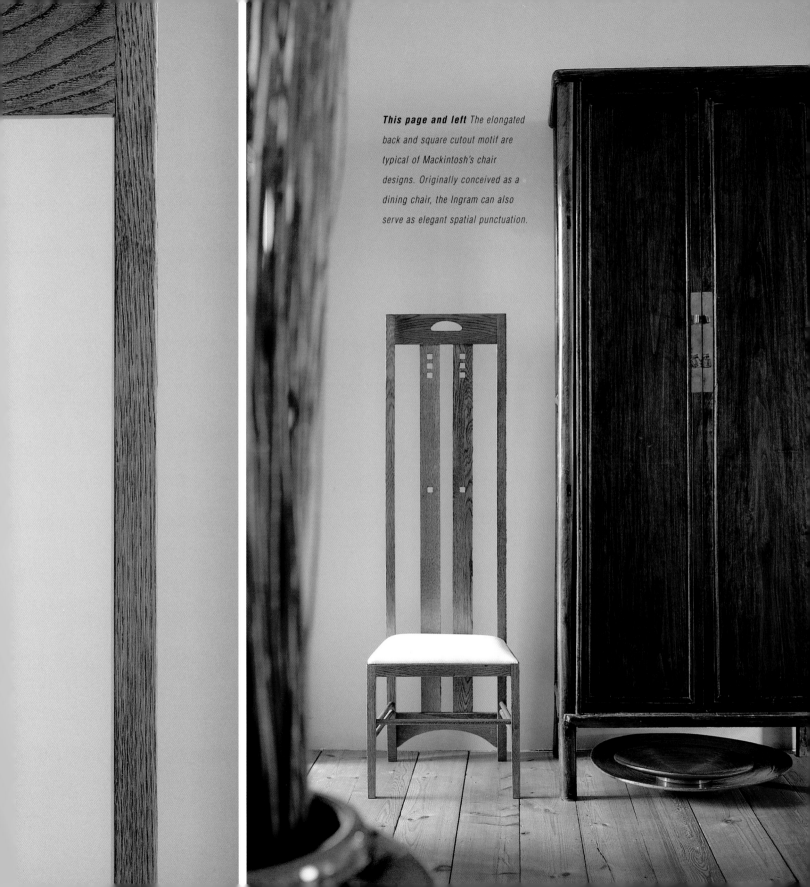

This page and left *The elongated back and square cutout motif are typical of Mackintosh's chair designs. Originally conceived as a dining chair, the Ingram can also serve as elegant spatial punctuation.*

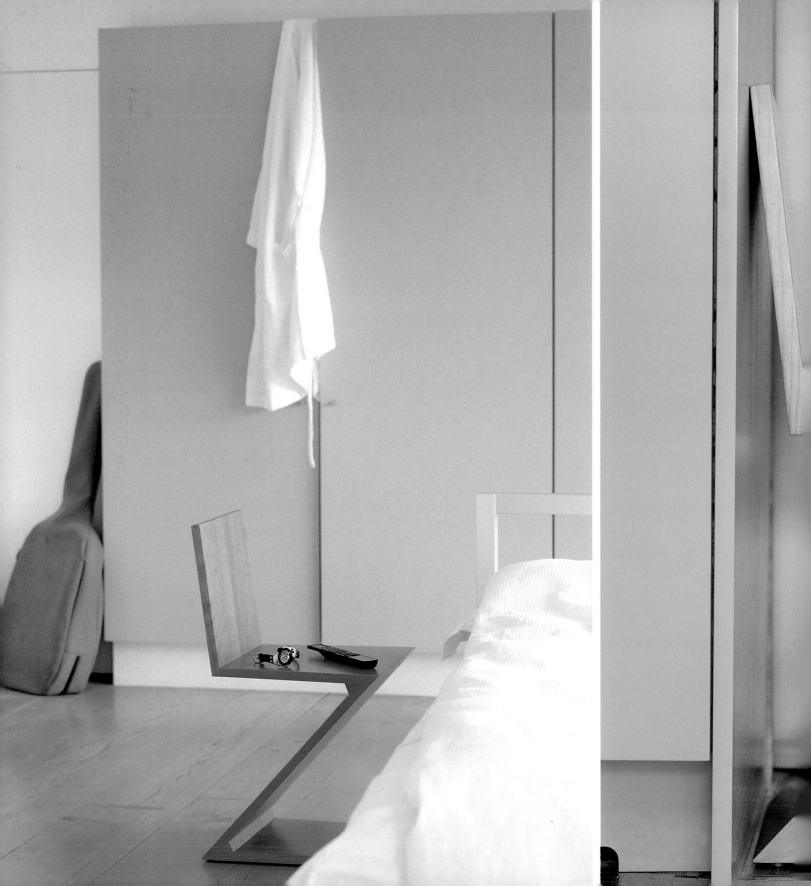

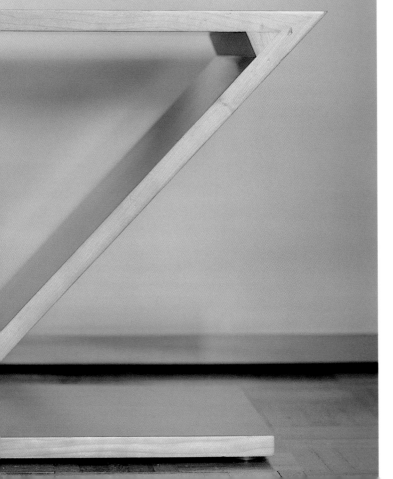

This page and opposite The impression may be of a continuous use of material, but the chair is in fact intricately constructed from four separate sections. The Zigzag may provide little comfort as a permanent perch, but as a graphic marker it is second to none.

GERRIT
RIETVELD 1888–1964

Born in Utrecht, where he lived and worked all his life, Gerrit Rietveld learned cabinetmaking from his father. After leaving his father's employment in 1911, Rietveld trained variously as an architectural draftsman, a designer, and finally as an architect, setting up his own practice in 1919. But it was the Red/Blue Chair, which he designed in 1917, for which he will probably be best remembered.

Nothing like the Red/Blue Chair had ever existed before. With its intersecting planes and formal geometric composition emphasized by color, the chair summarized the radical proposals of De Stijl, the progressive Dutch art and design movement. Rietveld's most important architectural work, the Schroder House (1924), also dates from this early period. Its rigorous geometries and open-plan layout, articulated with screens and panels of color, form an equally powerful expression of the new aesthetic. Rietveld continued to design chairs throughout his career, experimenting at various times with different materials, such as plywood, fiberboard, aluminum, and bent metal. His Crate chair (1935) was a low-cost self-assembly piece made of sections of packing crate.

Zigzag chair (1934)
Manufacturer: reissued by Cassina in 1971

Like the Red/Blue Chair, the Zigzag was conceived as a way of articulating space, as a marker within an interior. Rietveld wanted to design a chair from a single piece of material—an ambitious aim that would only be realized decades later in plastic. Instead, the Zigzag is made of four rectangular sections of elmwood, intricately dovetailed, glued and bolted together in a rather complex assembly that reveals Rietveld's background in cabinetmaking.

The simplicity of the Zigzag chair reflects Rietveld's interest in abstraction, the cantilever principle clearly expressed in its purest and most essential form. Small, spare, and austere, the chair was originally produced only in natural wood, but later examples were painted white, with contrasting red or green edges.

EERO SAARINEN 1910–1961

The son of famous Finnish architect Eliel Saarinen, Eero Saarinen was born in Helsinki and immigrated with his family to the United States in 1923. After studying sculpture in Paris and architecture at Yale University, Saarinen took up a teaching post at the Cranbrook Academy of Art, Michigan, a progressive and influential institution cofounded by his father. Here he collaborated with Charles Eames, who had been appointed head of experimental design in 1937. In 1940, a molded plywood chair designed by Eames and Saarinen won first prize at the Museum of Modern Art's "Organic Design in Home Furnishings" competition.

Saarinen was in the forefront of the American design movement that included Harry Bertoia and Noguchi, designers who tempered the severe functionalism of European modernism with an organic sense of form. Many of his most famous chair designs, including the Womb chair (1946–48), were manufactured by Knoll. His best-known architectural work, the TWA terminal at John F. Kennedy Airport, New York (1962), conveys a similar interest in the sculptural potential of materials.

Left, center, and opposite The sculptural beauty of the Tulip chair is particularly evident when the design is combined with its matching table. In a contemporary setting, the organic shape and pristine finish have a space-age modernity, while in a period room the design's basis in natural forms make it equally sympathetic.

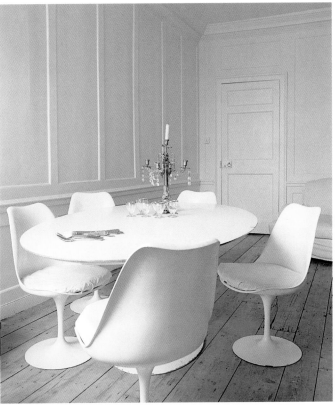

Tulip chair (1955–57)

Manufacturer: Knoll

The Tulip Chair was produced as one of the Pedestal group of designs, a set of chairs and tables conceived as unified forms. Saarinen had come to object to the "metal plumbing" of modern chairs, where molded seats were supported by a "slum of legs."

The limitations of plastics technology ultimately frustrated Saarinen's intention to produce a one-legged chair that consisted of a single molded plastic form. Instead, the Tulip chair is a two-part design. The body of the chair consists of a molded fiberglass shell and loose cushion, which is supported by a cast aluminum base. The base of the chair is plastic-coated to provide visual unity.

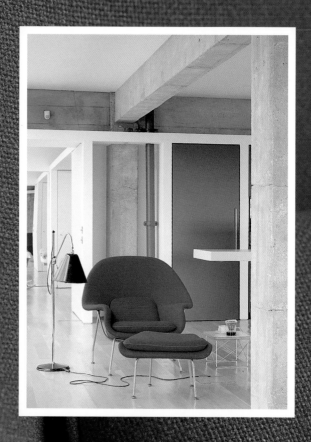

Womb chair (1946–48)

Manufacturer: Knoll

As the name suggests, this chair was designed to offer both physical and psychological security—a place to curl up and relax. How the human body can best be supported by furniture was one of Saarinen's particular interests, and this design demonstrates his great skill in achieving a high degree of comfort without creating a form that is awkward and clumsy-looking.

The basic shell consists of a single piece of molded fiberglass mounted on a framework of slender bent steel rods. The shell is covered in foam and upholstered; the two separate cushions, for the seat and back, are made of upholstered foam. The chair is accompanied by a matching ottoman, which also has a separate cushion.

Left and opposite Supportive, enclosing, and utterly comfortable, the Womb chair perfectly accommodates the body in repose and relaxation. The molded seat shell has an elegant fluidity that contrasts markedly with the spindly limbs of the bent steel framework.

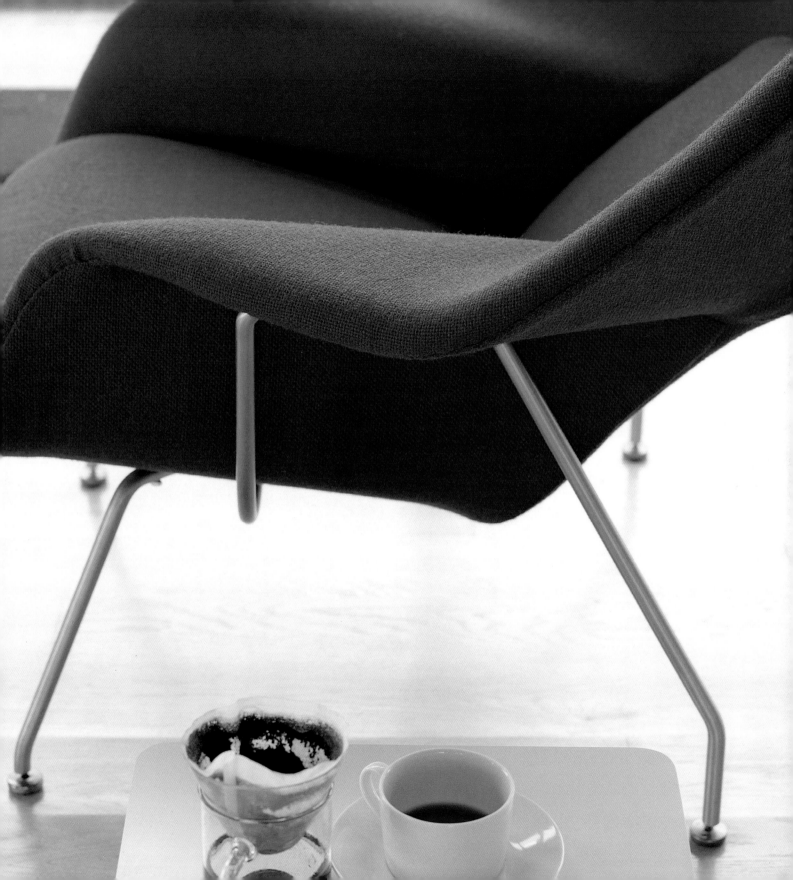

Left, center, and opposite A chair with a great deal of bounce, the springy S33 is one of the earliest examples of the cantilever form and has been much imitated. The fabric or leather seat and back are held in place by lacing *(left)*.

MART STAM 1899–1986

Born in Purmerund, Dutch architect and designer Mart Stam was closely associated with both the Bauhaus and Russian Constructivism. He studied drawing in Amsterdam from 1917 to 1919 and worked in an architectural practice before moving to Berlin and becoming involved with the Bauhaus. Like many early Modernists, he was a fervent believer in the power of modern technology and design to improve society and the conditions of ordinary people. Between 1930 and 1934, Stam worked as a town planner in the Soviet Union and later taught architecture and design in Dresden and East Berlin.

The idea of a cantilever chair appears to have occurred to Stam, Breuer, and Mies van der Rohe around the same time. A certain amount of controversy surrounds the issue of which designer was actually first. Breuer, whose Cesca chair was undoubtedly the most commercially successful, has often claimed precedence, but other sources maintain that Mart Stam was working on a prototype as early as 1924. What is clear is that all three designers met and shared ideas at the Deutsche Werkbund in 1927. In the 1930s, the British firm PEL (Practical Equipment Limited) manufactured a version of a cantilever chair that became a utilitarian standard in schools, hospitals, and other institutions.

S33 side chair (1926)

Manufacturer: SCP

The cantilever chair defined the machine aesthetic, borrowing what was then a new industrial material, tubular steel, to create a radical departure in furniture design. Instead of four legs, the chair has two supports, and the springy frame balances the weight of the body from front to back. Stam's original prototype of 1924 is said to have been made with lengths of cast-steel gas pipes connected with plumber's elbow joints since he did not at this time have access to the technology that would have enabled him to bend a continous length of tube.

The 1926 version, now reissued, is made of lacquered cast tubular steel reinforced internally with solid metal rods.

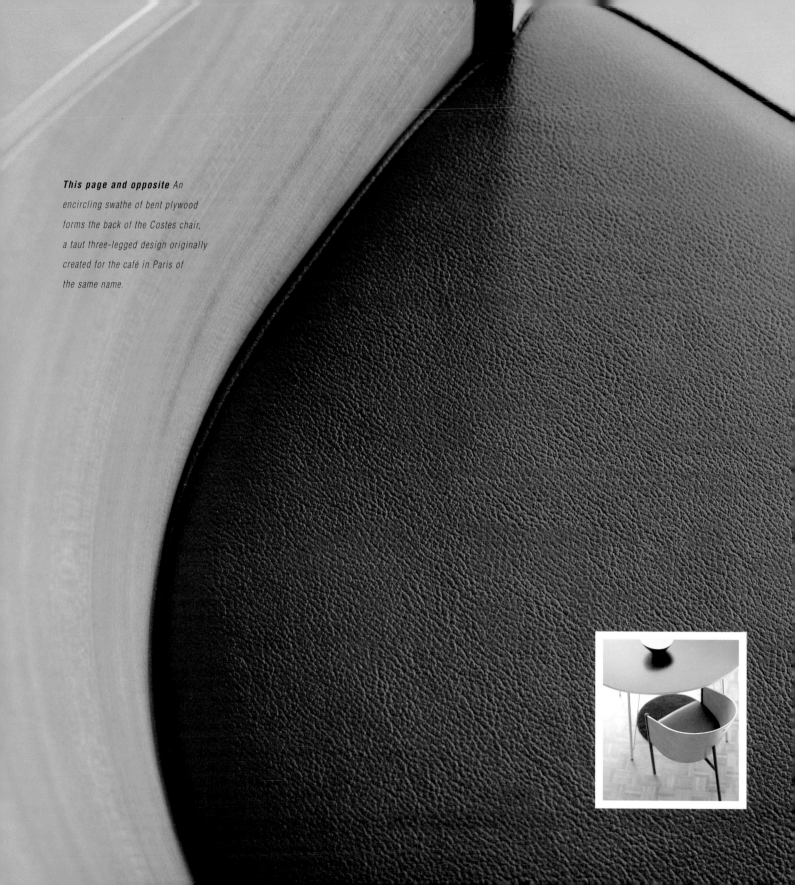

This page and opposite An encircling swathe of bent plywood forms the back of the Costes chair, a taut three-legged design originally created for the café in Paris of the same name.

PHILIPPE
STARCK b.1949

Philippe Starck was born in Paris and studied furniture and interior design at the Camondo School. In 1969 he was appointed artistic director of Pierre Cardin; by the late 1970s, when he founded Starck Products, he was becoming well known in France, one of a number of young designers who benefited from the state's support of design as a way of modernizing national identity. In 1983 he was among those chosen to design interiors at the Elysee Palace for President Mitterand.

Starck's 1982 commission to design the furniture and interiors of the Café Costes in Paris shot him to international recognition, and he has subsequently attained the status of a design superstar, with commissions all over the world. He produced a series of chairs during the 1980s for companies such as Driade, Disform, Vitra, and Idee; more recently his hotel interiors—the Royalton, New York (1988), the Peninsula, Hong Kong (1995), and the Delano, Miami (1995)—have won him widespread fame. Starck's work, from entire buildings to humble everyday objects like toilet brushes, displays an interest in zoomorphic form, together with an underlying humor. Miss Sissi, a table light designed in 1990, and Juicy Salif (designed in 1990 for Alessi), a juicer in the form of a predatory sci-fi insect, are both contemporary design icons.

Costes chair (1982)

Manufacturer: Driade, Italy

Starck's design for the interior and furnishings of the Café Costes, near the Beaubourg Centre in Paris, won him immediate attention from the design press. This three-legged chair has since become one of his best-known chair designs and epitomizes 1980s chic. Starck's designs, many of which feature taut, organic forms, are utterly contemporary in spirit, but their emotional, associative qualities represent a move away from the deterministic machine aesthetic of modernism.

Like many other Starck chairs, the Costes chair features a curved back, here made of bent mahogany plywood; the seat is foam, upholstered in leather. The frame is made of painted tubular steel.

Dr. No (1996)
Manufacturer: Kartell

Starck has recently dedicated himself to "morality" in design, which means, in his terms, designing basic, cost-effective, long-lasting products whose manufacture will not harm the planet. This new preoccupation is reflected in the "Good Goods" line of products, launched in 1998, and available by mail order. The flared shape of this chair reveals Starck's witty, organic play with form; its timeless quality, however, already hints at his interest in affordable basics. Dr. No comprises a single seat made of batch-dyed polypropylene mounted on sturdy aluminum legs. Up to four units can be stacked.

Lord Yo (1994)
Manufacturer: Driade

Lord Yo, which is also stackable, resembles an updated version of the traditional Lloyd Loom basket chair. The use of polypropylene, however, provides an elegant refinement of form and makes the chair light and portable. For many designers, ecological design means working with natural materials, but for Starck the future is "synthetic, synthetic, synthetic." Synthetic materials, such as the polypropylene used for the seat shell of this chair, can be used in small quantities and will last a long time. Both Dr. No and Lord Yo cost a seventh of the price of Starck's first commercially successful chair, the Café Costes.

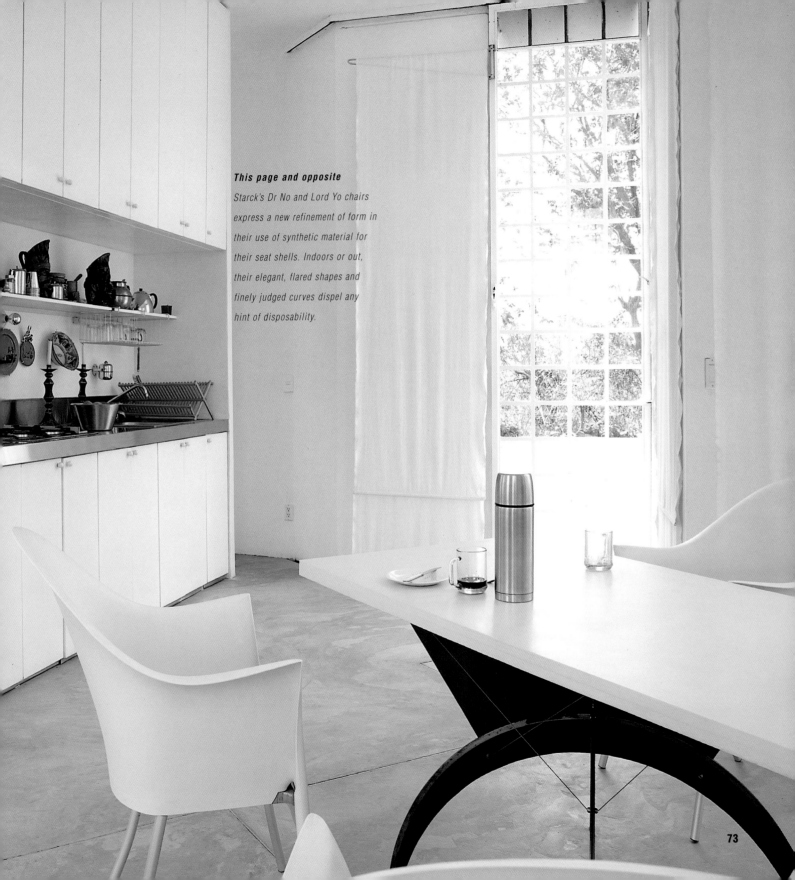

This page and opposite

Starck's Dr No and Lord Yo chairs express a new refinement of form in their use of synthetic material for their seat shells. Indoors or out, their elegant, flared shapes and finely judged curves dispel any hint of disposability.

HANS
WEGNER b.1914

Danish-born designer Hans Wegner emerged from the Scandinavian craft tradition to become one of the leading figures in establishing Danish Modern as an important postwar aesthetic. A cabinetmaker by training, he studied architecture and applied arts in Copenhagen before working with Arne Jacobsen and Eric Moller from 1938 to 1943. In 1943 Wegner established his own practice in Gentofte.

Wegner began an association with furniture company Johannes Hansen in the early 1940s, and most of his designs were subsequently produced by them or by Fritz Hansen. During the course of his career, he designed over 500 chairs, but it was his early work, including the Chinese chair (1944), the Y (Ypsilon) or Wishbone chair (1950), and the Round or Classic chair (1949), which won world recognition for the new Danish blend of modernism and tradition. Wegner's craft background gave him an affection for wood, a material used in many of his designs, while his commitment to modernism led him to rework traditional forms, such as the Windsor chair, in ways more attuned to contemporary lifestyles.

This page and bottom opposite
Lovingly crafted and infinitely appealing, the Y or Wishbone chair is Wegner's bestselling piece.
Top opposite *With its distinctive "horns" and four spindly legs planted firmly on the ground, the Ox truly lives up to its name.*

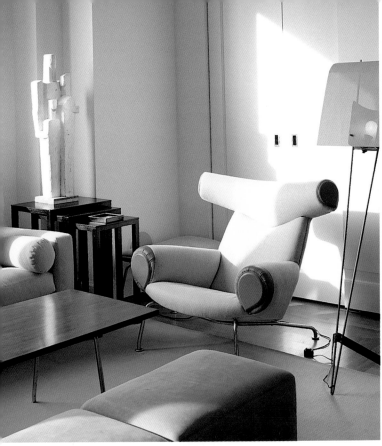

Ox chair, model no. EJ100 (1960)

Manufacturer: reissued by Erik Jørgensen, Copenhagen, from 1992

Powerful and distinctive, with a decidedly masculine presence, the Ox lounge chair is reputedly Wegner's personal favorite in his home. Low-slung and plushly upholstered, the Ox is designed to be roomy and inviting, offering maximum freedom of movement to its occupant. Its materials—leather and tubular steel—and form represented a departure from the norm for Wegner, who generally prefers to concentrate his efforts on more traditional solid-wood pieces.

Y chair, model no. 24 (1950)

Manufacturer: Carl Hansen & Son, Odense, from 1950 to the present

Simple, light, elegant, comfortable, and essentially modest, the Y (or Wishbone) chair is Wegner's most commercially successful design. Despite its lightness and exquisite economy of form, the chair is strong and robust. The curving bow of the top rail meets the arms in a single fluid gesture; the legs are slightly tapered, at their thickest where they join the seat. The Y- or wishbone-shaped vertical bar that gives the chair its name reinforces the slender top rail and provides an unobtrusive backrest. The chair was originally produced in solid teak with an oak top rail, but has since been made in solid oak. The seat is fashioned from woven paper cord.

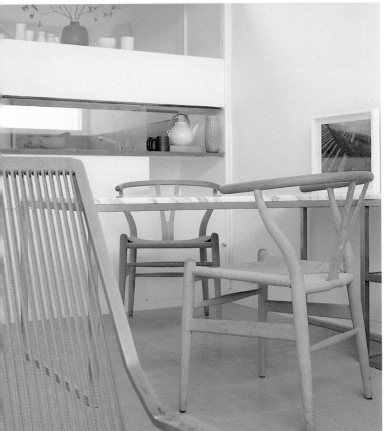

MARCO ZANUSO b.1916

Leading Italian postwar designer Marco Zanuso was born in Milan and graduated in architecture from Milan Polytechnic in 1939. After the war, in 1945, he established his own design practice and soon after became both a director of the influential magazine *Domus* and editor of *Casabella*. He was also responsible for the design of a number of Milan Triennales.

In 1948 Zanuso was asked by the Pirelli tire company to investigate the potential of foam rubber as a material for furniture upholstery. The results of his researches and the dramatic forms he was able to achieve with his innovative prototypes led to Pirelli establishing a new company, Arflex, in 1950 in order to put Zanuso's designs into production. Of the new material Zanuso wrote: "One could revolutionize not only the system of upholstery but also the structural manufacturing and formal potential."

Zanuso proved no less innovative in his product design. In 1957 he began a design collaboration with Richard Sapper, which resulted in a distinguished line of products and appliances, including radios, televisions, kitchen equipment, and pens. His architectural work includes factories and offices for Olivetti.

Lady chair (1951)

Manufacturer: Arflex

The Lady chair, awarded a Gold Medal at the Milan Triennale of 1951, was one of the early designs produced by the newly formed Arflex company. With its "visually exciting and new contours" (in Zanuso's words), the original form of the chair won it widespread publicity. Like the Antropus, the first Zanuso design Arflex ever produced, the Lady's organic curves dramatically announced the potential of the new material. The enclosing arms, with their slightly indented sides, accentuate the embracing comfort of the design.

The chair consists of a wooden frame upholstered in foam rubber and covered in fabric. The jaunty angled legs are made of slender lengths of chromed tubular metal.

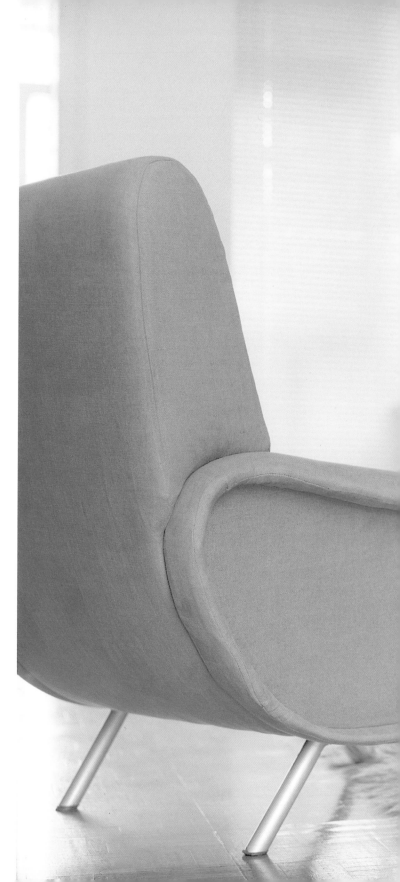

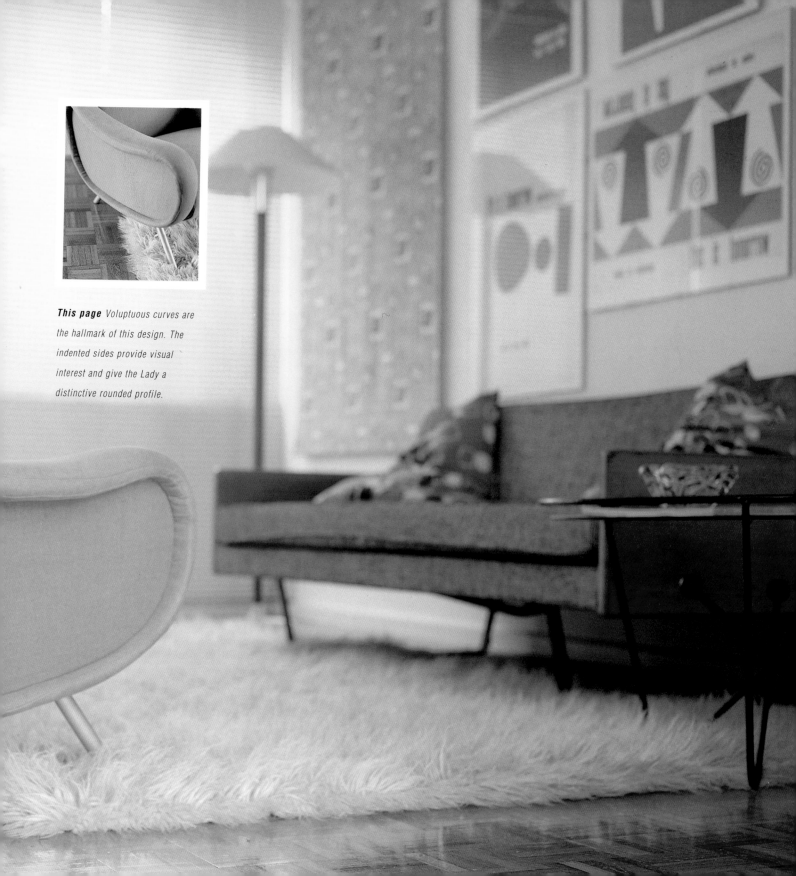

This page *Voluptuous curves are the hallmark of this design. The indented sides provide visual interest and give the Lady a distinctive rounded profile.*

RETAILERS

Cappellini
212-966-0669
*Manufacturers of Dixon's S chair
and other classics. Call for details
of a retailer in your area.*

Cassina USA Inc
155 East 56th Street
New York, NY 10022
800-770-3568
*The manufacturers of many of this century's
most classic pieces, including chairs by
Bellini, Le Corbusier/ Perriand, Mackintosh,
and Rietveld.*

Design Centro Italia
1290 Powell Street
Emeryville, CA 94608
510-420-0383
www.italydesign.com
*Classic chairs by Eames, Le Corbusier, Breuer,
and Mies van der Rohe sold on the internet.*

Design Within Reach
455 Jackson Street
San Francisco, CA 94111
800-944-2233
www.dwr.com
*Furniture from contemporary and classic
designers sold on the internet.*

European Furniture Importers
2145 Grand
Chicago, IL 60612
800-283-1955
e-mail: info@eurofurniture.com
*A mail-order discount house that carries chairs
by Aalto, Bellini, Bertoia, Le Corbusier/Perriand,
Eames, Gray, Jacobson, Mies van der Rohe,
Morrison, Mackintosh, Rietveld, and Stam, and
will special order others.*

Full Upright Position
1200 NW Everett
Portland, OR 97209
800-431-5134
www.f-u-p.com
*Carefully chosen modern classics for sale on
the internet. Call for a catalog. They can locate
and order chairs not included in their catalog.*

Gadgeteer
7337 Douglas Street
Omaha, NE 68114-4625
402-397-0808
www.gadgeteerusa.com
Buy Herman Miller chairs on the internet.

Fritz Hansen A/S
Allerodvej 8
DK 3450 Allerod
Denmark
+ 45 48 172 300
www.fritzhansen.com
*Manufacturers of chairs by Arne Jacobsen
and Poul Kjaerholm. Phone for details of
their US distributor.*

Hille Furniture
Cross Street, Darwen
Lancs BB3 2PW, England
+ 44 1254 778 851
www.hille.co.uk
*Manufacturers of Robin Day chairs.
Call to order or purchase from their website.*

ICF Group
800-237-1625
www.icfgroup.com
*Distributors of Aalto chairs manufactured by
Artek. Call the above number for details of their
showroom in New York or a retailer in your area.*

Knoll International
105 Wooster Street
New York, NY 10012
212-343-4000
www.knoll.com
*Manufacturers of furniture by Mies van
der Rohe, Breuer, Saarinen, and Bertoia,
among others.*

Herman Miller
www. hmstore.com
Visit this website if you want to buy
modern classics over the internet
www.hermanmiller.com
This website will give you details
of a retailer in your area
*Manufacturer of modern classics including
the Eames Lounge chair.*

Modern Age
102 Wooster Street
New York, NY 10012
212-966-0669
A selection of modern classics.

Modern Living
8775 Beverly Boulevard
Los Angeles, CA 90048
310-657-8775
www. modernliving.com
*Furniture by Cassina, Classicon, and
Zanotta, among others.*

Modernica
7366 Beverly Hills Boulevard
Los Angeles, CA 90036
310-933-0383
A selection of contemporary classics.

The Morson Collection
31 St. James Avenue
Boston, MA 02116
617-482-2355
and at
100 East Walton Street
Chicago, Il 60611
312-587-7400
*Large collection of Bauhaus classics.
Call 800-204-2514 for a free catalog.*

Race Furniture
Bourton Industrial Estate
Bourton-on-the-Water
Glos GL54 2HQ
England
+ 44 1451 821446
*Manufacturers of Race chairs.
Call for details of how to order.*

Retro Modern
1037 Monroe Drive NE
Atlanta, GA 30306
404-724-0093
www.retromodern.com
*Furniture by several European manufacturers,
including Kartell.*

Sedia
63 Wareham Street
Boston, MA 02118-2428
800-Bauhaus
617-451-2474
e-mail: sedia@world.std.com
*Furniture by Bertoia, Breuer, Le
Corbusier/Perriand, Eames, Gray, Mackintosh,
Mies van der Rohe, Rietveld, and Saarinen.*

ARCHITECTS AND DESIGNERS whose work has been featured in this book:

Jules Seltzer & Associates
8833 Beverly Boulevard
Los Angeles, CA 90048
310-274-7243
www.jules-seltzer.com
A 10,000 sq. ft showroom displaying the finest in contemporary classic furniture, including Knoll Studio.

Sunset Settings
1714 Sunset Boulevard
Houston, TX 77005
713-522-7661
www.sunsetsettings.com
Modern classic furniture. Visit their website and order over the internet.

Vitra Inc.
149 Fifth Avenue
New York, NY 10010
212-539-1900
Manufacturers of chairs by Gehry, Morrison, and Panton. Call for details of their showrooms in New York and San Francisco or a retailer in your area.

**Claire Bataille &
Paul ibens Design**
Vekestraat 13 Bus 14
2000 Antwerpen
Belgium
+ 32 3 213 86 20

Briffa Phillips
19–21 Holywell Hill
St Albans
Herts AL1 1EZ
+ 44 1727 840 567

Brookes Stacey Randall
New Hibernia House
Winchester Walk
London SE1 9AG
+ 44 20 7403 0707

Ian Chee VX Designs
+ 44 20 7370 5496

Justin de Syllas
Avanti Architects Ltd.
1 Torriano Mews
London NW5 2RZ
+ 44 20 7284 1616

Hudson Featherstone Architects
49–59 Old Street
London EC1V 9HX
+ 44 20 7490 5656

Kelly Hoppen Interiors
2 Alma Studios
32 Stratford Road
London W8 6QF
+ 44 20 7938 4151

Johnson Naylor
+ 44 20 7490 8885
b.j.j.n@btinternet.com

Steven Learner Studio
138 West 25th Street
12th Floor
New York, NY 10001
001 212 741 8583

McDowell & Bendetti Architects
62 Rosebery Avenue
London EC1R 4RR
+ 44 20 7278 8810

Orefelt Associates Ltd
Portbello Studios
5 Hayden's Place
London W11 1LY
+ 44 20 7243 3181

Andrew Parr
SJB Interior Design
P. O. Box 1149
3205 South Melbourne
Australia
+ 03 9688 2122

Charles Rutherfoord
52 The Chase
London SW4 0NP
+ 44 20 7627 0182

Shelton, Mindel & Associates
216 18th Street
New York, NY 10011
USA
001 212 243 3939

Seth Stein Architects
51 Kelso Place
London W8 5QQ
+ 44 20 7376 0005

Stephen Varady Architecture
Studio 5, 102 Albion Street
Surry Hills
2010 Sydney, NSW
Australia
+ 02 9281 4825

Will White
326 Portobello Road
London W10 5RU
+ 44 208 964 8052

Woolf Architects
39–51 Highgate Road
London NW5 1RT
+ 44 207 428 9500

ACKNOWLEDGMENTS

All photographs by Andrew Wood unless otherwise stated

Key: **t** = top, **b** = below, **l** = left, **r** = right, **c** = center
1 Annette Main and Justin De Syllas' house in London; **2** The penthouse at Millennium Harbour, London designed by CZWG Architects and Johnson Naylor, photographed courtesy of Alan Selby & Partners; **3 c** Tom Leighton/Siobhan Squire and Gavin Lyndsey's loft in London, designed by Will White; **3 r** Stephan Schulte's loft in London; **4** chair courtesy of Race Furniture; **5 t** chair courtesy of Vitra; **5 b** chair courtesy of Coexistence, 020 7354 8817; **6** Century, 020 7487 5100; **7** Nigel Smith's loft in London; **8** Freddie Daniells' loft in London, designed by Brookes Stacey Randall Architects, chair courtesy of SCP; **9 tl** Stephan Schulte's loft in London; **9 tr** chair courtesy of Vitra; **9 br** Coexistence, 020 7354 8817; **10–11** Coexistence, 020 7354 8817; **12 tl** Century, 020 7487 5100 **12 bc** Stephan Schulte's loft in London; **12 r & 13** Coexistence, 020 7354 8817; **14** Henry Bourne/a house in London designed by Charles Rutherfoord; **14 inset & 15** Ian Chee's apartment in London, chair courtesy of Geoffrey Drayton; **16** the loft of Peggy and Steven Learner, designed by Steven Learner Studio; **17** Annette Main and Justin De Syllas' house in London; **20 l & c** Coexistence, 020 7354 8817; **20 inset r** Annette Main and Justin De Syllas' house in London; **21** Coexistence, 020 7354 8817; **22–23** Stephan Schulte's loft in London; **24 tl** Century, 020 7487 5100; **24 c** Annette Main and Justin De Syllas' house in London, chairs courtesy of Hille UK; **24 r** Caroline Arber/Siobhan Squire and Gavin Lyndsey's loft in London, designed by Will White, chairs courtesy of Hille UK; **25 & 26 tl** Annette Main and Justin De Syllas' house in London; **27** Coexistence, 020 7354 8817; **28–29** Freddie Daniells' loft in London, designed by Brookes Stacey Randall Architects, chair courtesy of SCP; **30–31 & 32** Century, 020 7487 5100 **33** Nigel Smith's loft in London; **33 inset t** James Merrell/Jan Staller's house in New York; **33 c** James Merrell; **33 b** Century, 020 7487 5100; **34 l** David Montgomery/Belinda and Guy Battle's house in London; **34–35** Neil Bingham's house in Blackheath, London; **36–37** Century, 020 7487 5100, chairs courtesy of Vitra; **38–39** The penthouse at Millennium Harbour, London, designed by CZWG Architects and Johnson Naylor, photographed courtesy of Alan Selby & Partners; **40** Freddie Daniells' loft in London, designed by Brookes Stacey Randall; **41 l&r** Ray Main/Jon Howells' apartment in London; **42–43** Ray Main/Seth Stein's house in London; **43 inset l** James Merrell/Andrew Parr's house in Melbourne; **43 inset c** James Merrell/Linda Parham and David Slobham's apartment in Sydney, designed by architect Stephen Varady; **43 r** James Merrell/Kelly Hoppen's apartment in London; **44** Coexistence, 020 7354 8817; **44 inset** Ian Chee's apartment in London; **45** Annette Main and Justin De Syllas' house in London, chair courtesy of Fritz Hansen; **46 l & 47r** Brian Johnson's apartment in London, designed by Johnson Naylor; **46–47 c** an apartment in Knokke, Belgium, designed by Claire Bataille and Paul ibens; **48–49** chair courtesy of SCP; **48 inset** Freddie Daniells' loft in London, designed by Brookes Stacey Randall, chair courtesy of SCP; **49 inset** an apartment in Bath, designed by Briffa Phillips Architects; **50 l** a house in London, designed by Orefelt Associates, design team Gunnar Orefelt and Knut Hovland; **50 bc & br & 51** Stephan Schulte's loft in London; **52–53** Century, 020 7487 5100, chair courtesy of Vitra; **54–55** Ian Chee's apartment in London, chair courtesy of Vitra; **56** Patricia Ijaz's house in London, designed by Woolf Architects; **57** Neil Bingham's house in Blackheath, London, chair courtesy of Hayworth; **58–59** Brian Johnson's apartment in London, designed by Johnson Naylor, chairs courtesy of Race Furniture; **60–61**, chair courtesy of Freud; **62** Freddie Daniells' loft in London, designed by Brookes Stacey Randall, chair courtesy of Geoffrey Drayton; **63** Ian Chee's apartment in London, chair courtesy of Geoffrey Drayton; **64 l & 64–65 main** Henry Bourne/Mr Glinsman's house in London, designed by McDowell + Benedetti Architects; **65 r** Henry Bourne/the flat of Ilse Crawford, **66–67** Nigel Smith's loft in London; **68–69** Century, 020 7487 5100, chair courtesy of SCP; **69** Freddie Daniells' loft in London, designed by Brookes Stacey Randall, chair courtesy of SCP; **70** Neil Bingham's house in Blackheath, London, chair courtesy of Purves & Purves, **71** chair courtesy of Purves & Purves; **72 l** Ian Chee's apartment in London, chair courtesy of Geoffrey Drayton; **72 r** Simon Upton/Baggy House, designed by Hudson Featherstone Architects; **73** Simon Upton; **74 & 75 b** Brian Johnson's apartment in London, designed by Johnson Naylor; **75 t** Ray Main/Lee F. Mindel's apartment in New York, designed by Shelton, Mindel & Associates with Associate Architect Reed Morrison, lighting designed by Johnson Schwinghammer; **76–77** Neil Bingham's house in Blackheath, London, chair courtesy of Designer's Guild; **80** chair courtesy of Coexistence, 020 7354 8817.

The publisher would like to thank everyone who kindly allowed us to photograph in their homes and all the retailers and manufacturers who loaned us items for photography. Special thanks to Andrew Weaving from Century, the team at Coexistence for all their help, and to Ahmed Sidiki from BOWWOW.

The author would like to thank Annabel Morgan, Ashley Western, Kate Brunt, and Andrew Wood for their creative efforts, enthusiasm and skill; with special thanks to Annabel for having the idea in the first place.